Born Into Brothels

নিষিদ্ধ পল্লীতে জাত

Born Into Brothels

Photographs by the Children of Calcutta
By Zana Briski

Umbrage Editions

DEDICATION

In honor of the women and
children of the red light district

Photograph by Suchitra

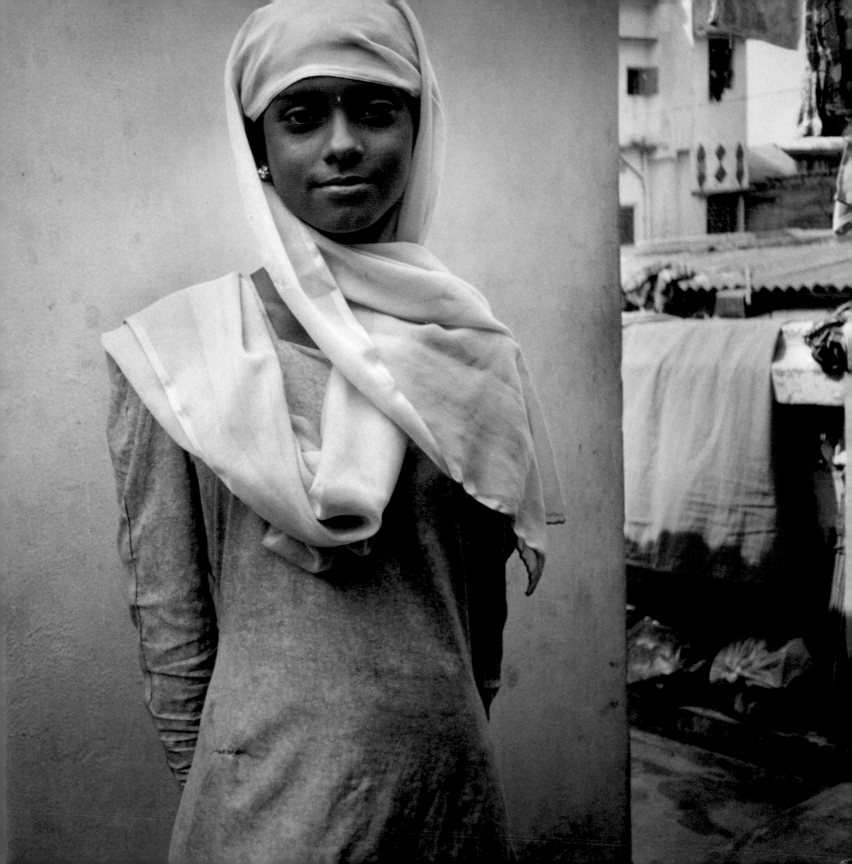

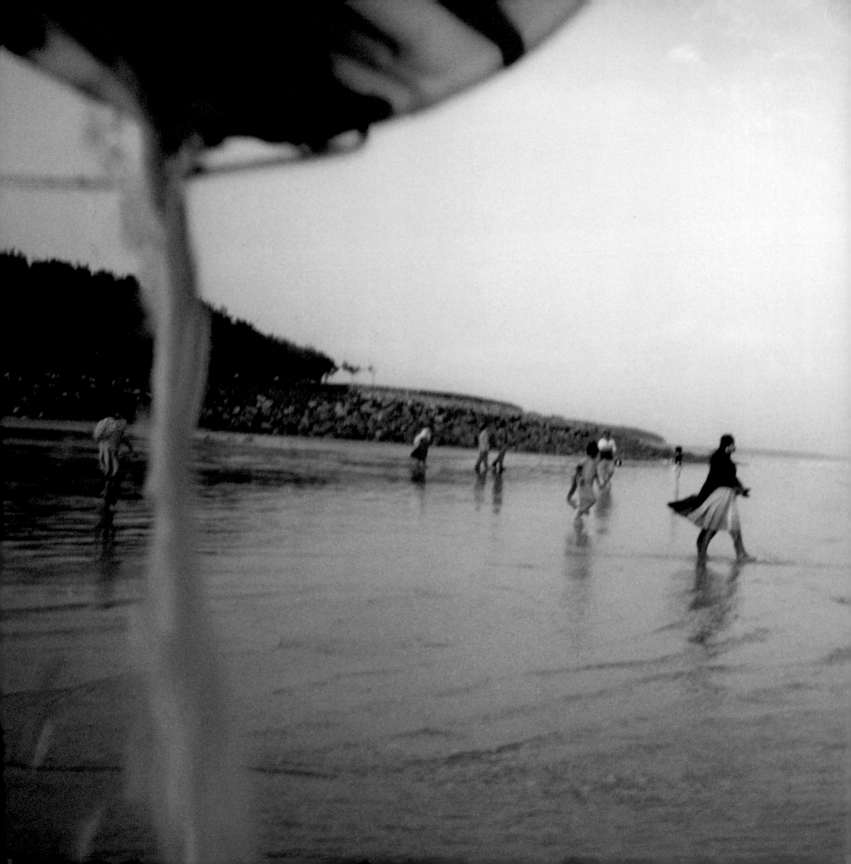

Table of Contents

Photograph by Avijit

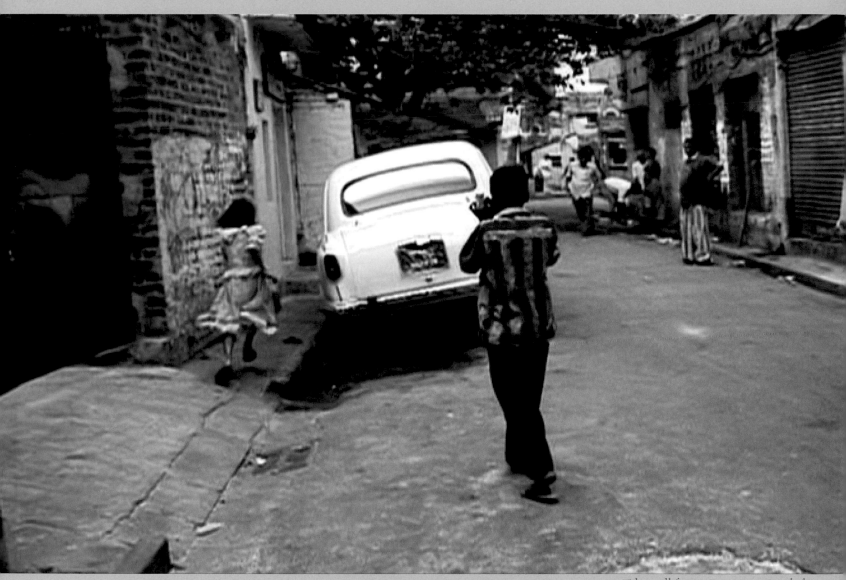

Film still from *Born Into Brothels*

ABOUT THE FILM

The most stigmatized people in Calcutta's red light district, are not the prostitutes, but their children. In the face of abject poverty, abuse, and despair, these kids have little possibility of escaping their mother's fate or for creating another type of life.

In *Born into Brothels*, directors Zana Briski and Ross Kauffman chronicle the amazing transformation of the children they come to know in the red light district. Briski, a professional photographer, gives them lessons and cameras, igniting latent sparks of artistic genius that reside in these children who live in the most sordid and seemingly hopeless world. The photographs taken by the children are not merely examples of remarkable observation and talent; they reflect something much larger, morally encouraging, and even politically volatile: art as an immensely liberating and empowering force.

Devoid of sentimentality, *Born into Brothels* defies the typical tear-stained tourist snapshot of the global underbelly. Briski spends years with these kids and becomes part of their lives. Their photographs are prisms into their souls, rather than anthropological curiosities or primitive imagery, and a true testimony of the power of the indelible creative spirit.

Diane Weyermann
Director, Documentary Film Program, Sundance Institute

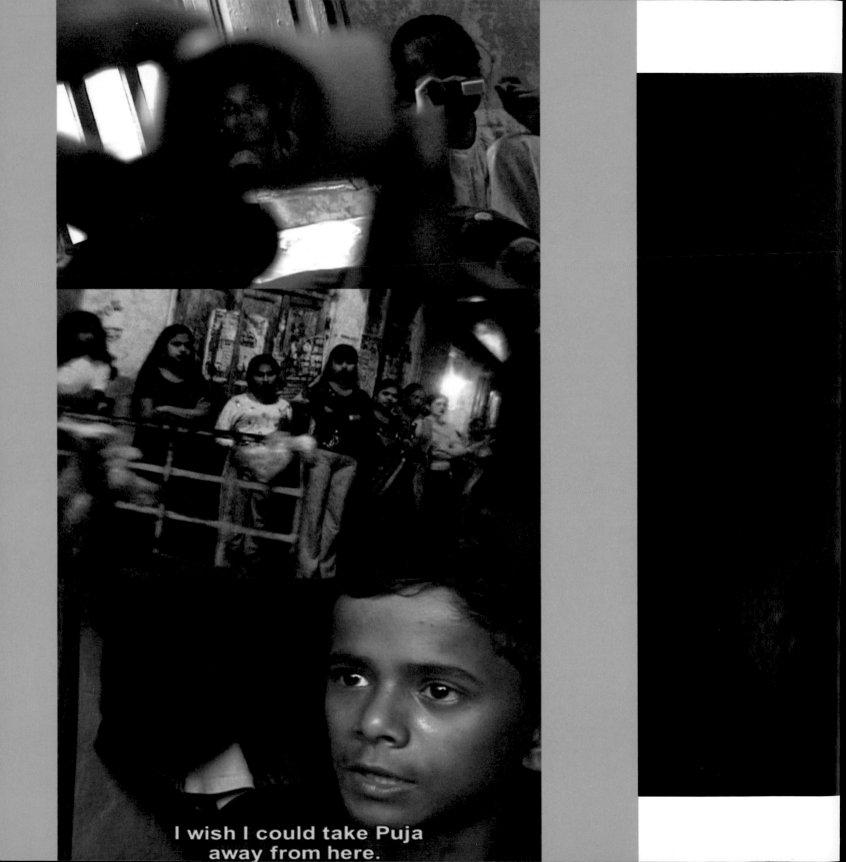

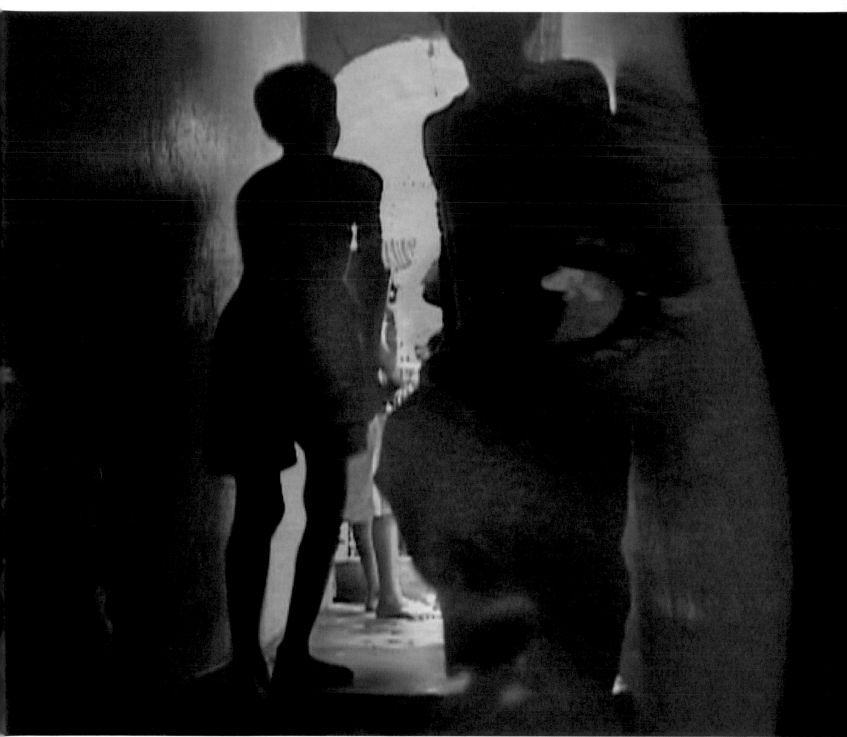

Film stills from *Born Into Brothels*

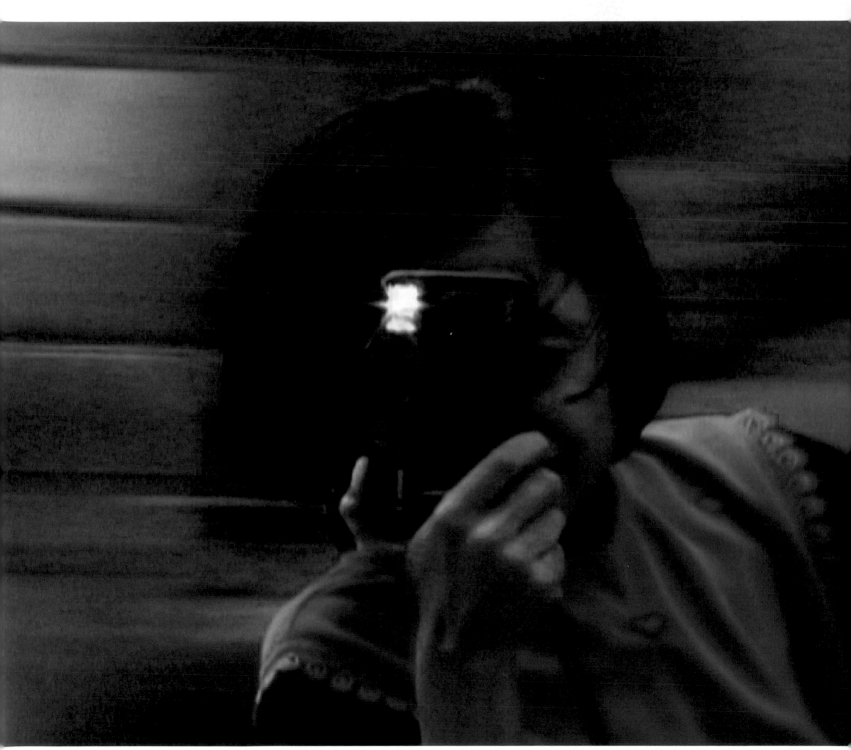

Film stills from *Born Into Brothels*

14

Film stills from *Born Into Brothels*

I wonder what I could become.

They're not coming back anymore,
they're not coming back...

DIRECTORS' STATEMENTS

Ross Kauffman

In the winter of 2000, Zana Briski, a photojournalist from New York City, asked me to collaborate on a project with her about the children of prostitutes in Calcutta. She had been teaching them photography for the previous two years, and decided that their stories were worthy of a film.

I had just quit editing documentaries after ten years and was successfully making the transition to working as a documentary cameraperson. Though I was intrigued by her offer, I passed on the project, feeling that I did not want to be a poor, struggling filmmaker for the next three to five years.

Zana then sent me four videotapes that she had shot in Calcutta for me to "critique" (she had never shot video before). Within the first ten minutes of viewing the first tape, I knew I was going to Calcutta.

I am eternally grateful to Zana and the kids for sharing their lives with me.

16

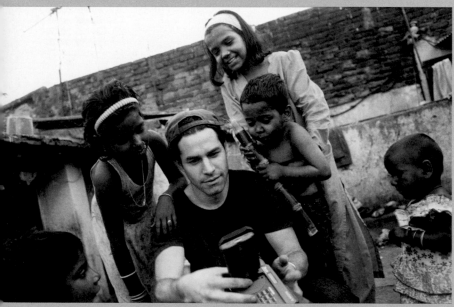

Photograph by Zana Briski

Zana Briski

In 1998 I began living with prostitutes in a squalid red light district of Calcutta. When I first went to India in 1995, I had no idea what lay ahead. I began to travel and photograph the harsh realities of women's lives—female infanticide, child marriage, dowry deaths, and widowhood. I had no intention of photographing prostitutes until a friend took me to the red light district in Calcutta. From the moment I stepped foot inside that maze of alleyways, I knew that this was the reason I had come to India.

I spent months trying to gain access to this impenetrable place. I knew I wanted to live with the women, to really understand their lives. Finally a brothel owner gave me a

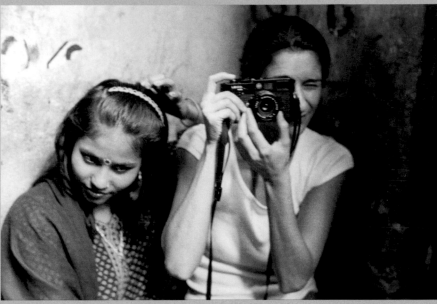

Photograph by Tumpa

room. It took a long time before I gained the trust of the women. As they waited for clients, I waited with them. I sat for hours on end, joking, playing, experiencing the tediousness and the volatile emotions that erupt where women find themselves trapped in an inescapable world, forced to sell affection in order to live and care for their children.

It was the children who accepted me immediately. They didn't quite understand what I was doing there, but they were fascinated by me and my camera. I let them use it and showed them how to take pictures. I thought it would be great to see this world through their eyes. It was then that I decided to teach them photography.

On my next trip, I brought ten point-and-shoot cameras and selected a group of kids who were most eager to learn. I had no idea what I was doing, but the kids loved it and turned up to class every week. And the results were amazing. I gave up my own photography and began to work with the kids full-time. I knew that there was something important to document here, so I bought a video camera (I had never picked up a video camera before) and began to film the kids in the brothels, in the streets, and on photo class trips.

I invited Ross Kauffman to Calcutta to come and make a film with me. He didn't want to come, so I sent him some of the tapes to look at, knowing that he would fall in love with the kids, as I had done. Soon after he was on a plane for Calcutta. He was worried about the story. I told him to wait. The story would reveal itself.

And it did.

KIDS WITH CAMERAS

While artists have always documented the world for us to see, photography has a particular way to help us see ourselves in each other—the beauty, the frailty and the truth of what is possible and what is so in this world.

I first learned about the power of photography teaching a literature and narrative writing course for Harvard undergraduates. For five glorious years I had the privilege of teaching with Dr. Robert Coles, whose syllabus included books and films that struggled with moral and social issues. He likened photography and the interpretations they evoke to the process he and Anna Freud used when they asked children to tell them the stories of their crayoned drawings. "Photography, like dreams, help us remember parts of ourselves," he told us.

The photographs in this book are themselves a classroom and have much to teach us. They are taken by children of prostitutes, children who have grown up surrounded by violence and clouded by a social stigma that denies them the right to an education. Cameras become windows to new worlds for these children, and for some, a door to a new life. Their pictures tell us without words how much they have seen, yet how innocent they long to remain.

Born Into Brothels is both a book and an HBO/THINK film that allow us to experience the transformative power of a good teacher and the study of art. The teacher was Zana Briski, a talented photographer whose work in 1997 took her to Sonagachi, the largest red light district of Calcutta. Once there, she knew she had to stay. Much like James Agee and Walker Evans, who set off on an innocent assignment to 'document the South' for *Forbes* magazine and twelve years later gave us a epic look at ourselves as a pre-civil rights nation, Zana wanted to understand the lives of sex workers in a way more intimate than traditional photojournalism.

But it was through the children that Zana truly came to know Sonagachi. They cajoled Zana away from her campaign "to help" the prostitutes. They followed her like the Pied Piper, fascinated by her work and images. One of her students, Gour, worried that the young girls would be next in line for prostitution, asked Zana to teach them her trade. Maybe the photography could help them find a different life, he dared hope. Zana continued her work as a photographer, creating beautiful, poignant images of her subjects—but her new work as a teacher consumed her. The children's fascination with the camera was fed by the triumph of self-discovery and an instantly recognizable, irrepressible talent. Over time they taught each other to see. Where she saw darkness and stark beauty, they saw explosions of color.

Armed with a portfolio, Zana returned to New York intermittently with a new mission: to get cameras and funding for the children's work. It took six years, some grant money, and a great deal of credit-card debt to continue their work together. Along the way she got support from Contact Press Images and Pixel Press, and the crazy idea to make a film of their stories. She sent footage to cinematographer/co-director Ross Kauffmann and soon he was on a plane and stopped in his tracks by the colors and chaos of Sonagachi. The Jerome Foundation, the Open Society Institute, and the Swartz and Fireman Foundations helped them hit benchmarks. They secured exhibits in Calcutta, an auction at Sotheby's and a calendar devoted entirely to the children's work via Amnesty International. A coveted invitation to the Sundance Director's Lab, and an investment infusion from their documentary fund helped legitimize these stories enough to become a film. HBO discovered the 'work in progress' at the Sundance Lab and bought the rights to distribute it domestically a week before acceptance into

the Sundance Film Festival. At Sundance it won the Audience Award and since has won the hearts of festivalgoers around the world. Each opportunity emboldened the children and the directors. Soon they will be telling their story to the world in theaters and broadcasts internationally.

As the legacy of all the lessons learned in Sonagachi, Zana started a nonprofit organization called Kids With Cameras. It has been the financial scaffolding that allowed this book and the film to exist. It is proud to have been part of a story that puts on record the power of a camera as a teaching tool and the importance of visual literacy in disenfranchised communities. Kids With Cameras now carries out the work of teaching the art of photography to children growing up in marginalized or disadvantaged circumstances. The organization creates a bridge between these children and the rest of the world, giving their visions a forum to be shared and experienced. It builds platforms for the children to exhibit their work, telling us their stories and transforming the children and their audience through the processes of instruction, creation, and experience.

We hope as audiences and educators, policymakers and philanthropists come to know the children in this book, some will be moved to support their work, their confidence, and their conviction. Some of you might be moved to buy some of their work, available on our on-line gallery on our website www.kids-with-cameras.org. Others might use the film and or the book as a teaching tool. Perhaps you will share these stories with your own children, encouraging them to tell you their dreams through pictures and stories.

Kids With Cameras has big dreams. Inspired by what these children have taught us, we dare to dreams in color. We hope you will be part of our future by supporting our work at any level and we thank you in advance. If you are moved to support us financially you can do so by sending a check to:

19

Kids With Cameras
341 Lafayette Street
Suite 4407
New York, NY 10012
info@kids-with-cameras.org

Geralyn White Dreyfous
Executive Producer,
Born Into Brothels
Founding Board Member,
Kids With Cameras

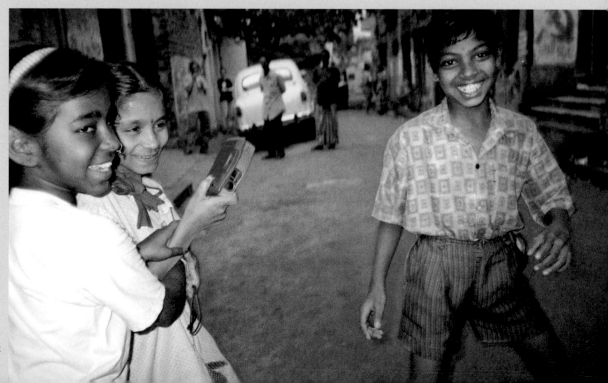

Photograph by Avijit

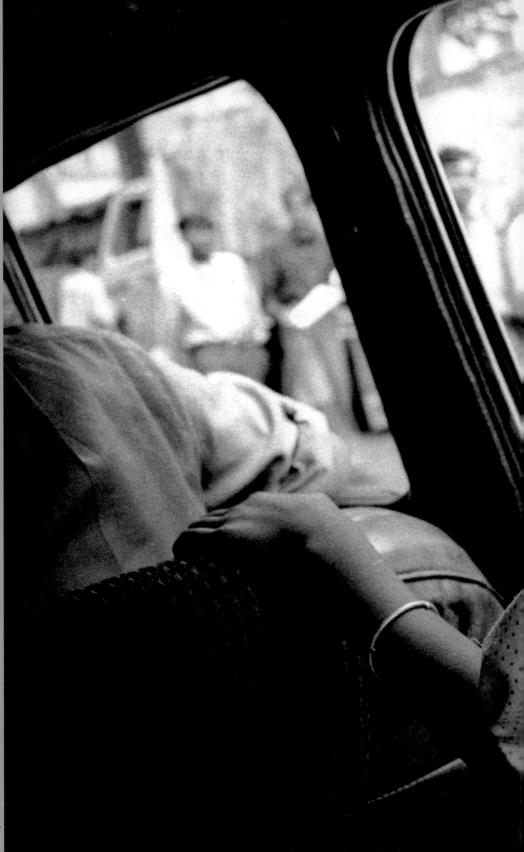

20

Photograph by Zana Briski

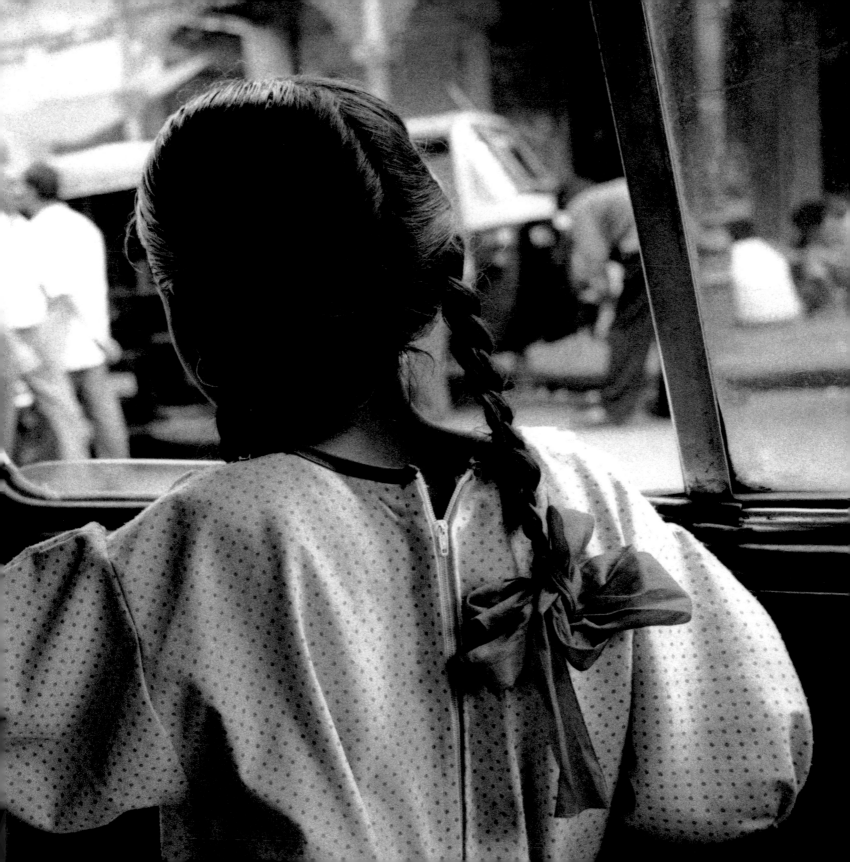

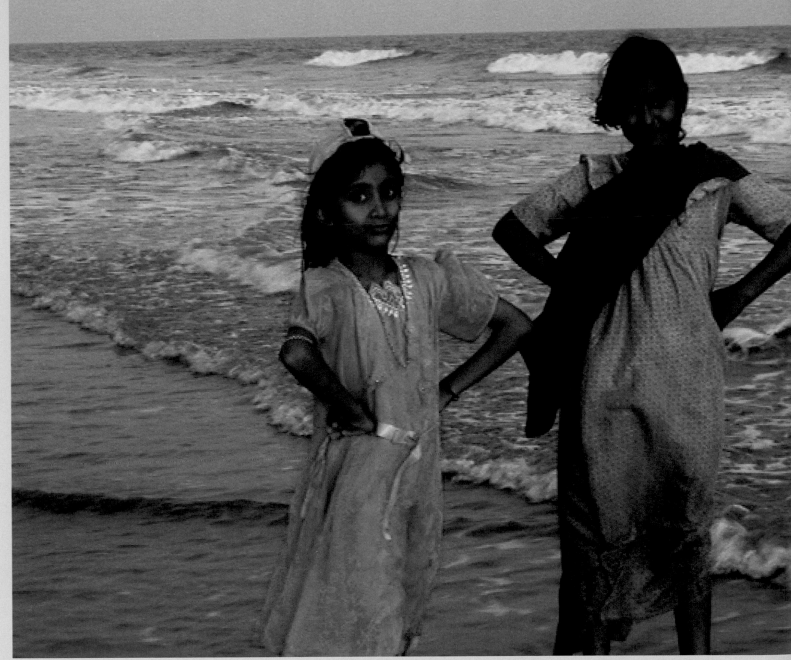

Film stills from *Born Into Brothels*

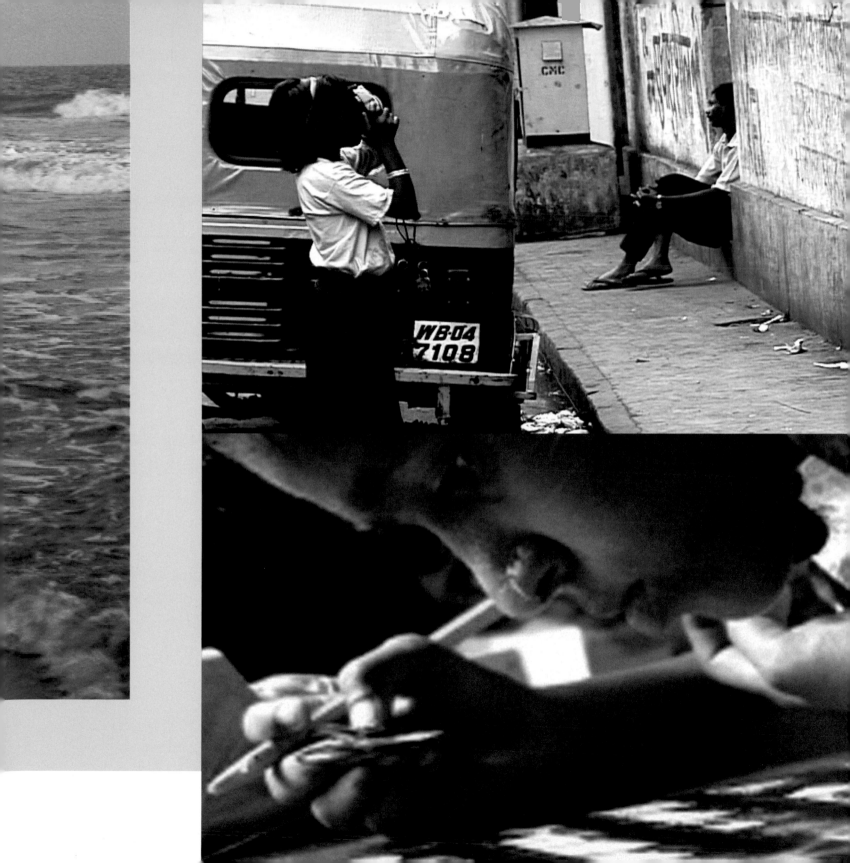

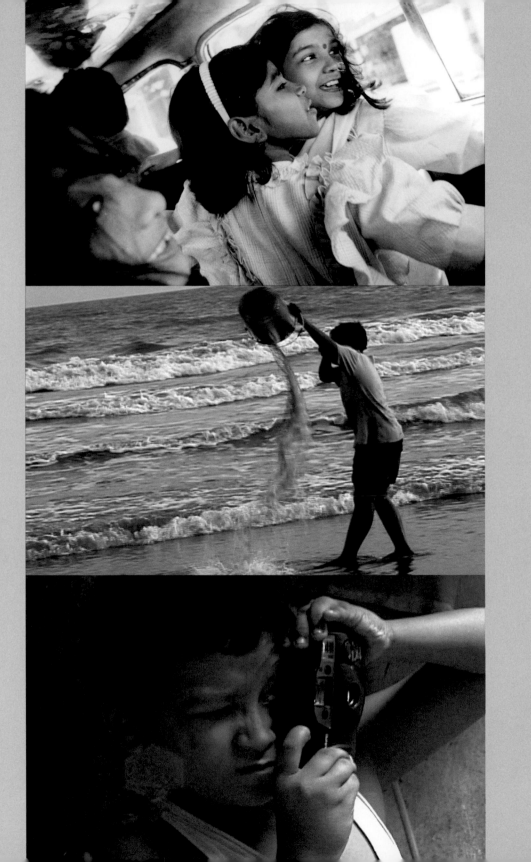
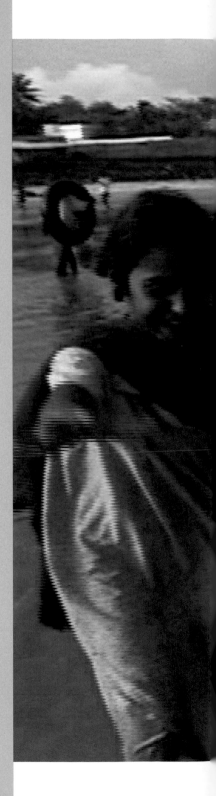

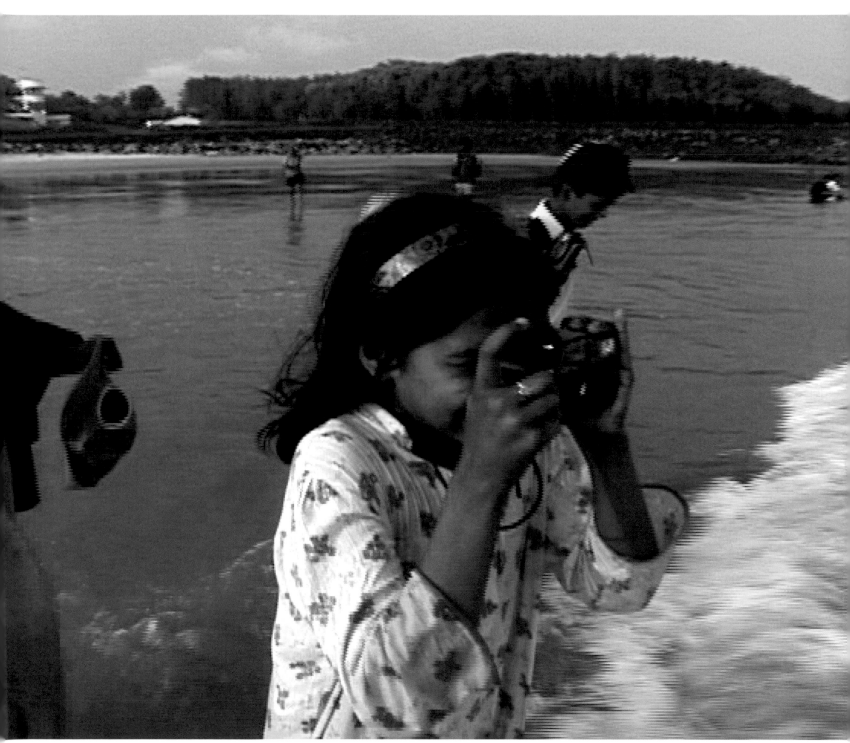

Film stills from *Born Into Brothels*

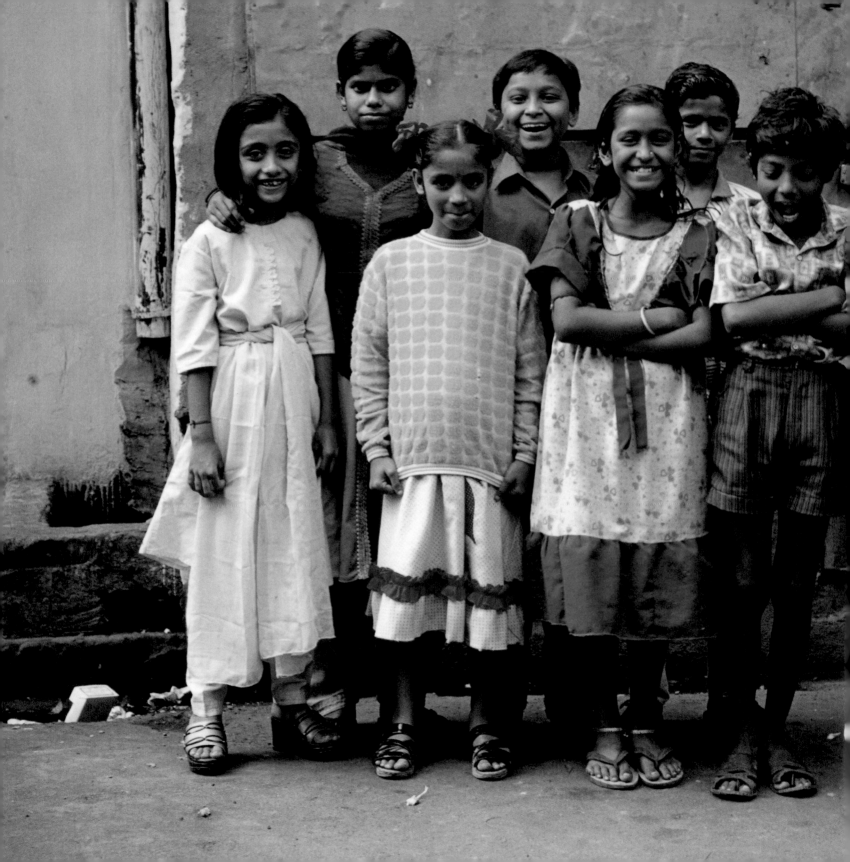

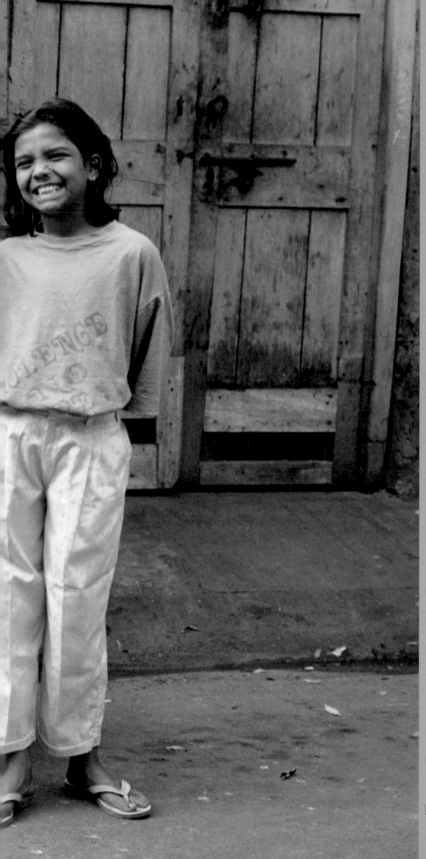

27

Photograph by Zana Briski

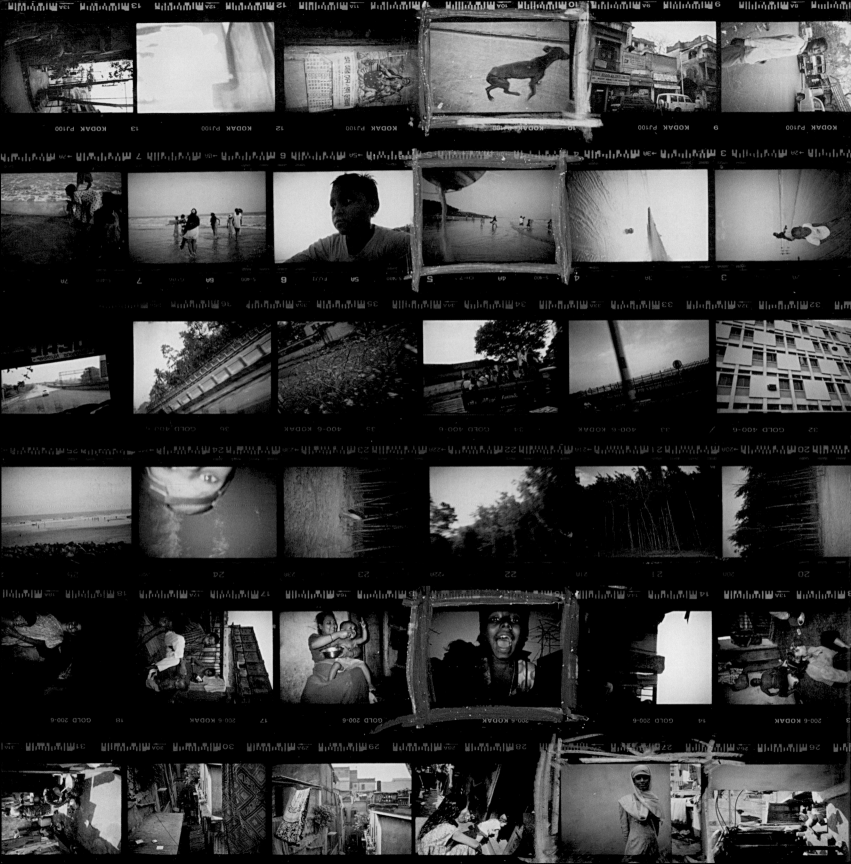

THE KIDS

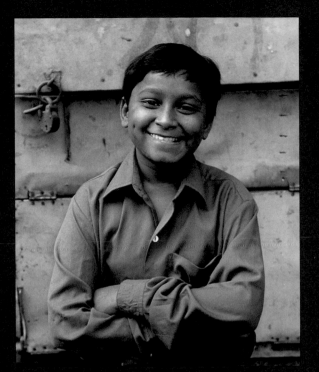

Avijit

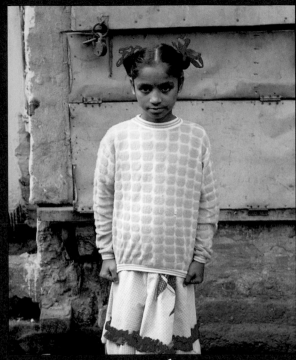

Kochi

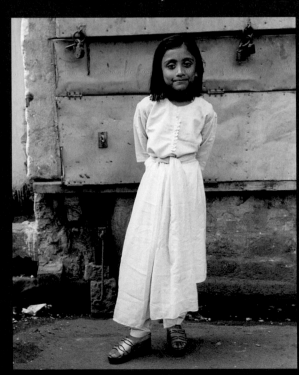

Puja

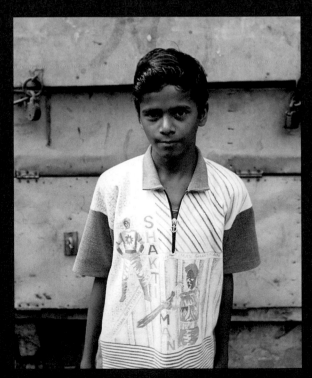

Gour

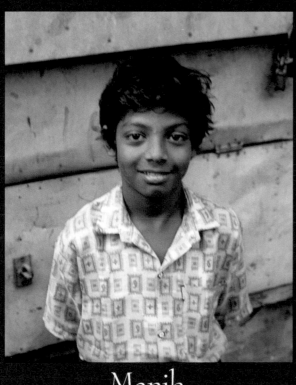

Manik

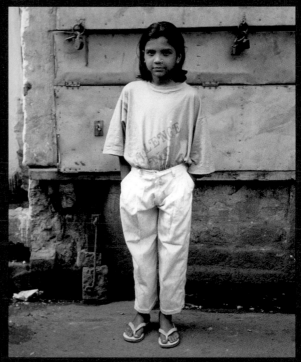

Shanti

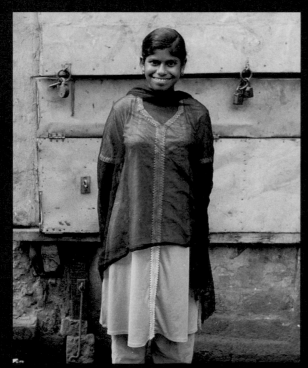

Suchitra

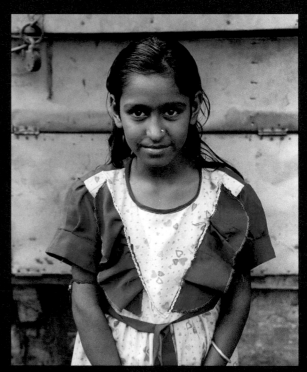

Tapasi

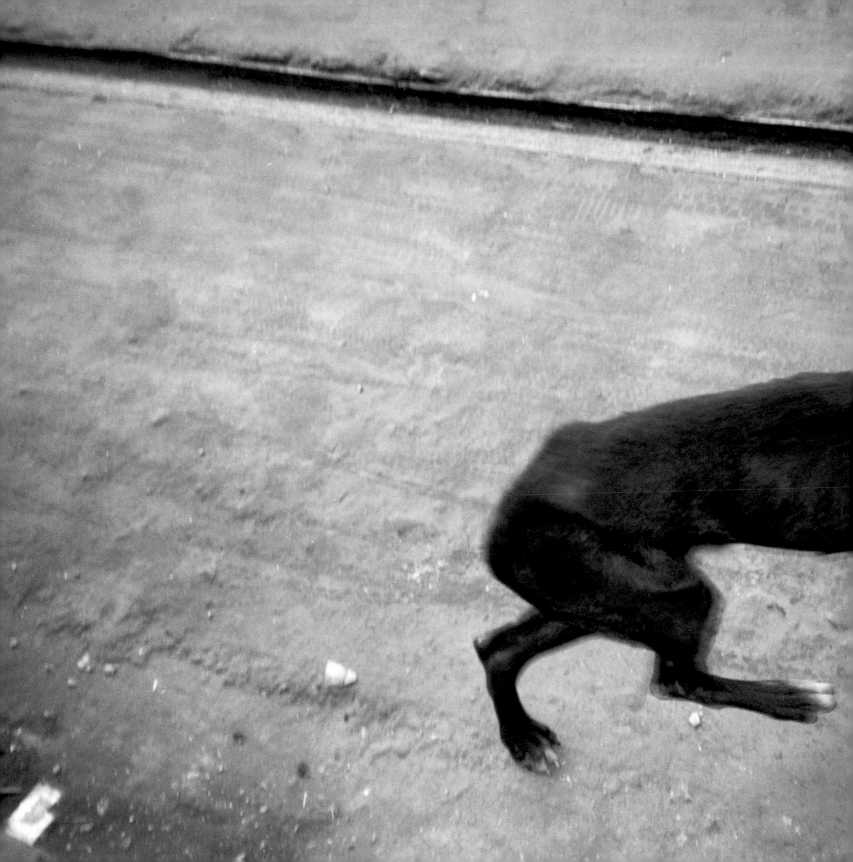

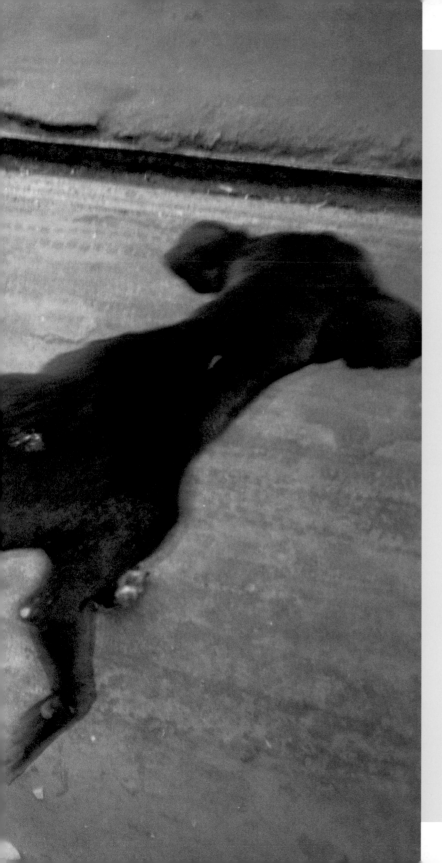

Avijit

Avijit, twelve, is an innately talented artist and has won many competitions for his paintings. Charismatic and restlessly creative, his images were among the most compelling of the workshop. Avijit was invited by the World Press Photo Foundation in Amsterdam to be part of their Children's Jury in 2002. After the class, Avijit declared, "I used to want to be a doctor. Then I wanted to be an artist. Now I want to be a photographer." Avijit now lives at the Future Hope home for boys and attends one of the best schools in Calcutta. He immediately saw photography as a vehicle for commentary and for exploration. Of his picture of a dog, he explains "This is a street dog, an Indian breed. It is so thin because it is half-starved. I took the picture when it jumped up seeing a car and it started running away scared."

33

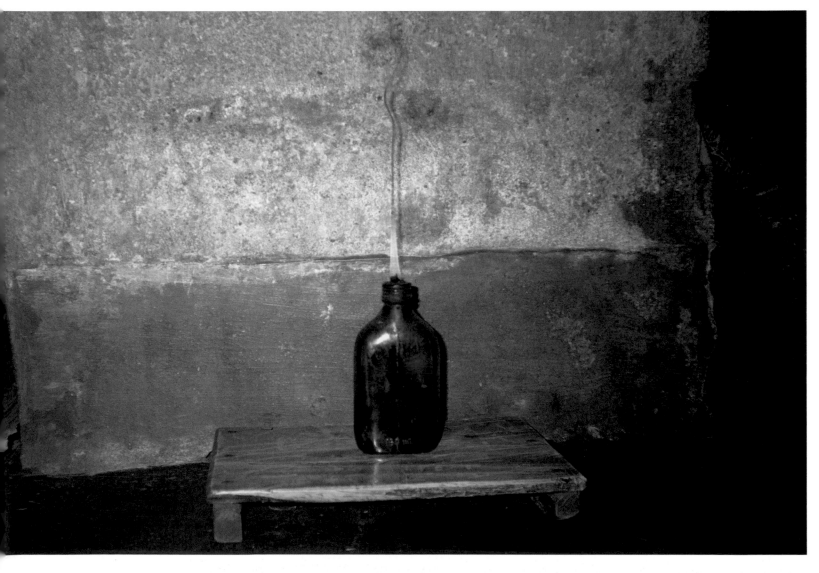

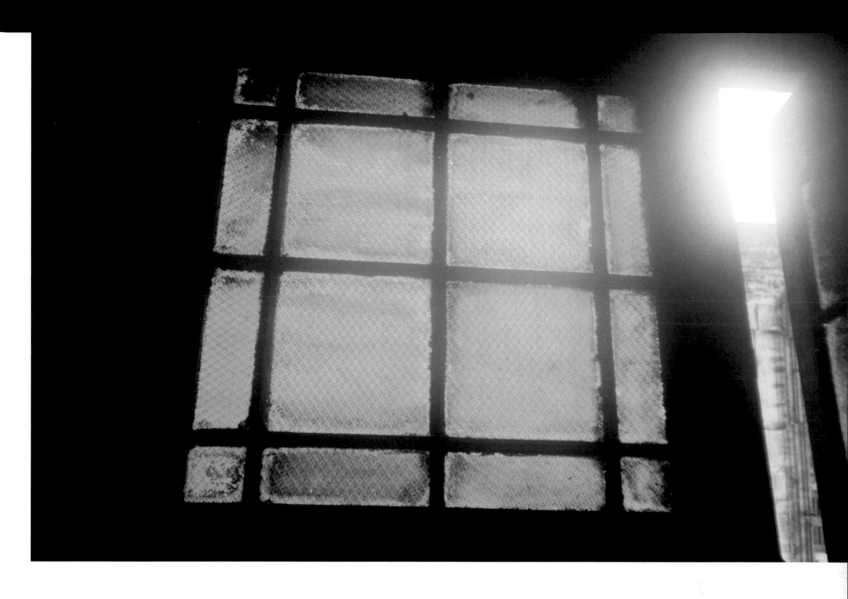

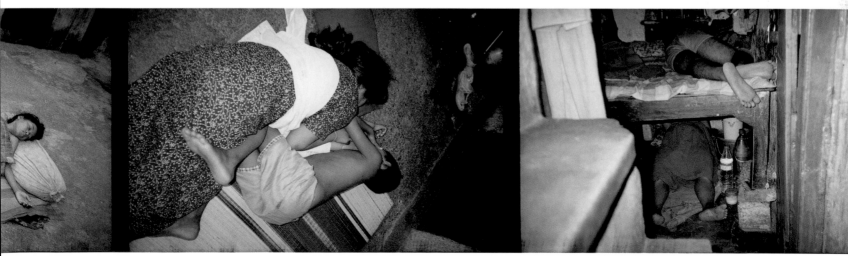

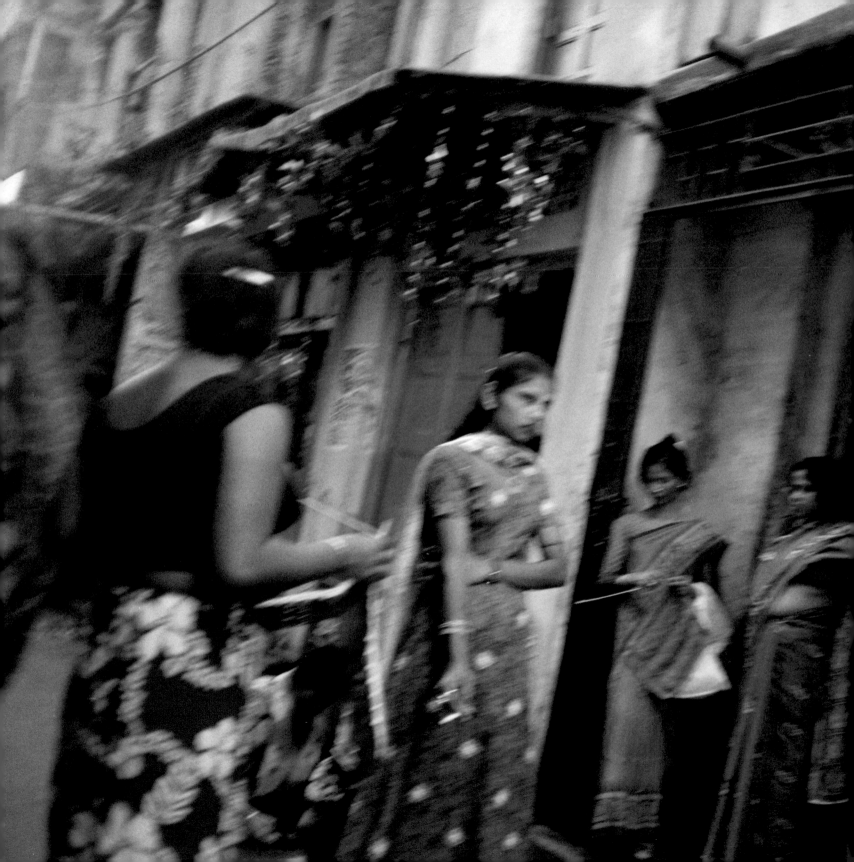

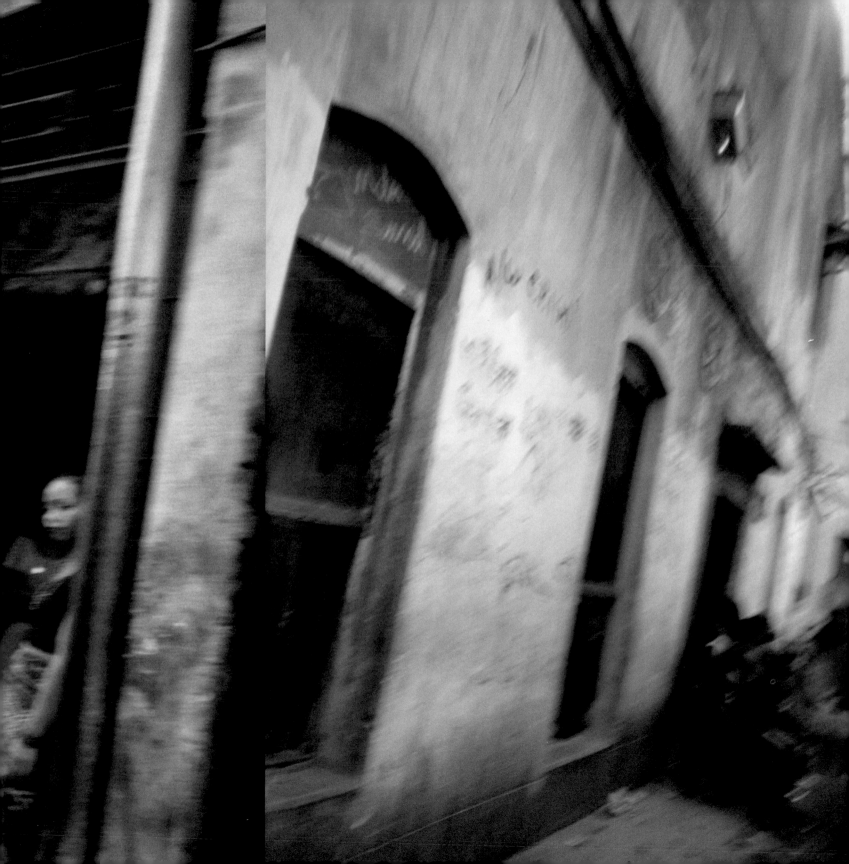

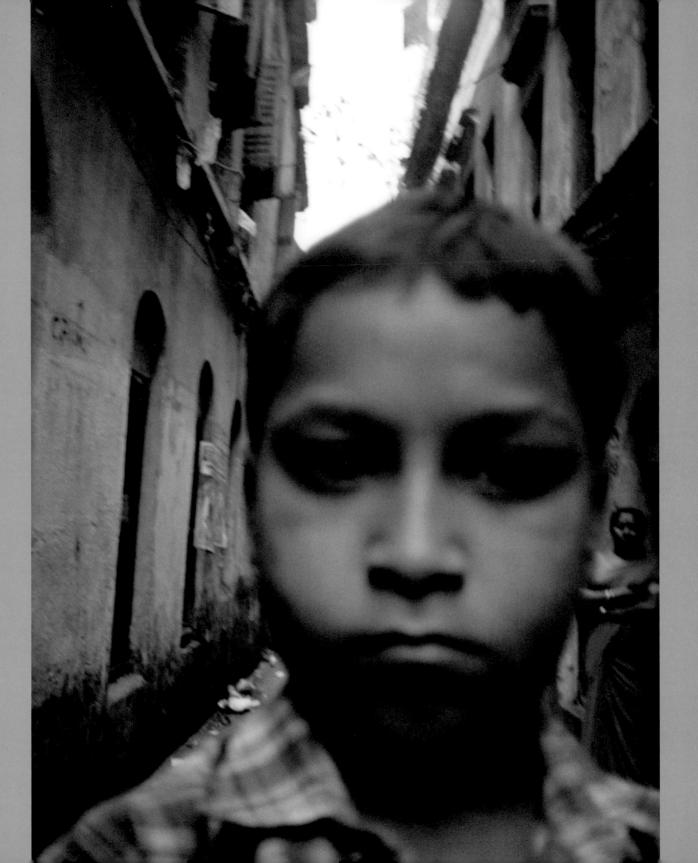

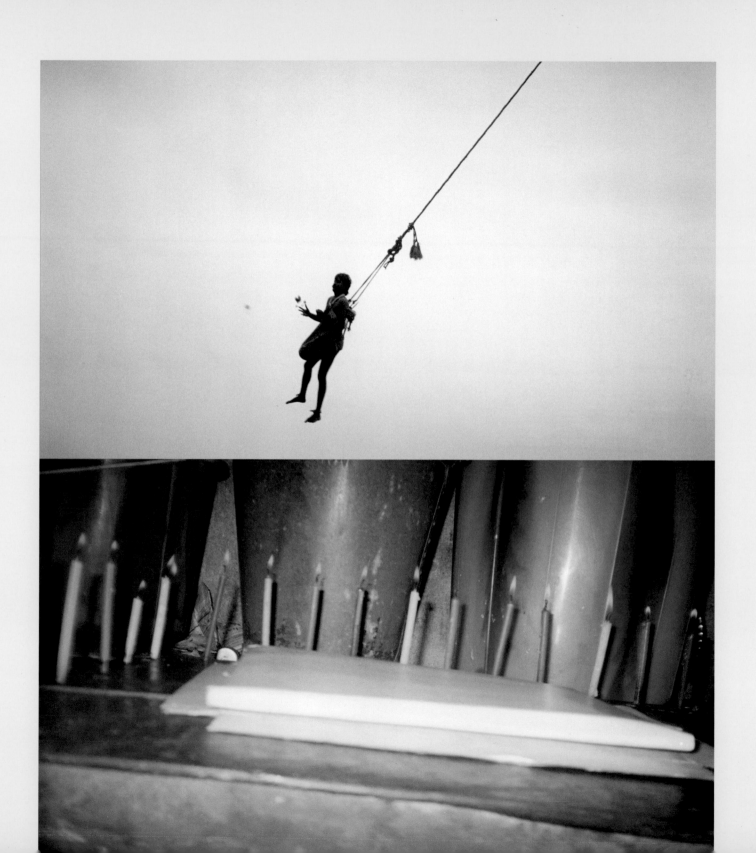

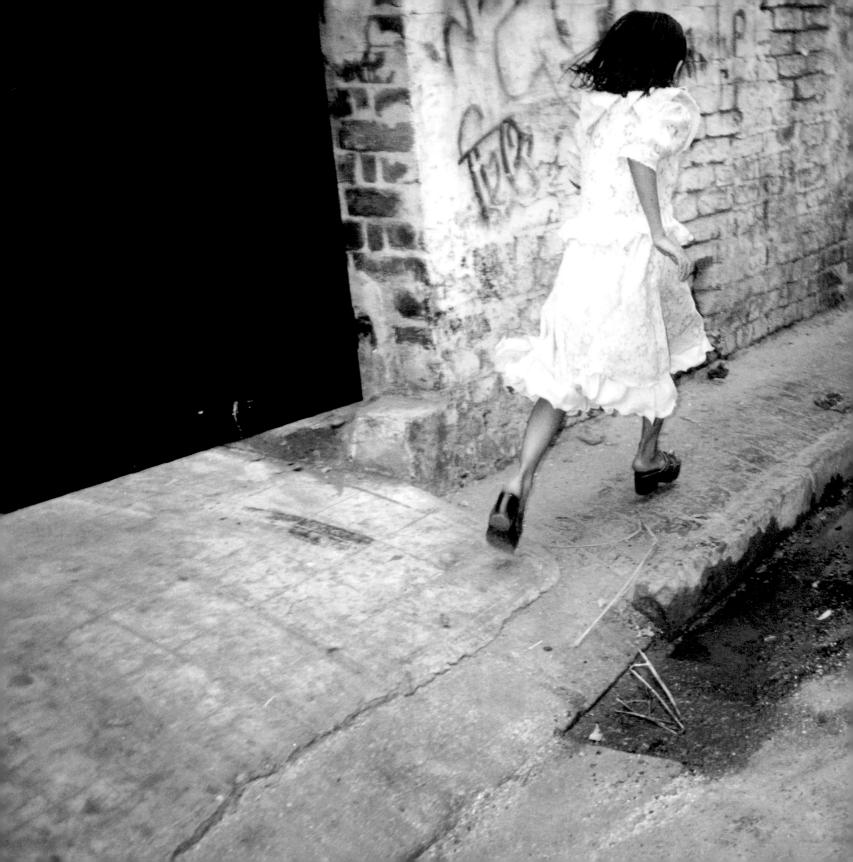

Gour

Gour, thirteen, is sensitive and thoughtful, responsible and wise. Concerned about the people who live alongside his mother, he is vocal about his dislike of the brothel environment and wants to use photography to change it. "I want to show in pictures how people live in this city. I want to put across the behavior of man." He chooses to photograph his friends playing cricket, his pet rabbits, and his best friend Puja. The bond of friendship between the Gour and Puja is visible to even a stranger. It is obvious that the two young people care about each other and look after one another with humor and tenderness. Gour hopes to go to university with the support of Kids With Cameras.

43

44

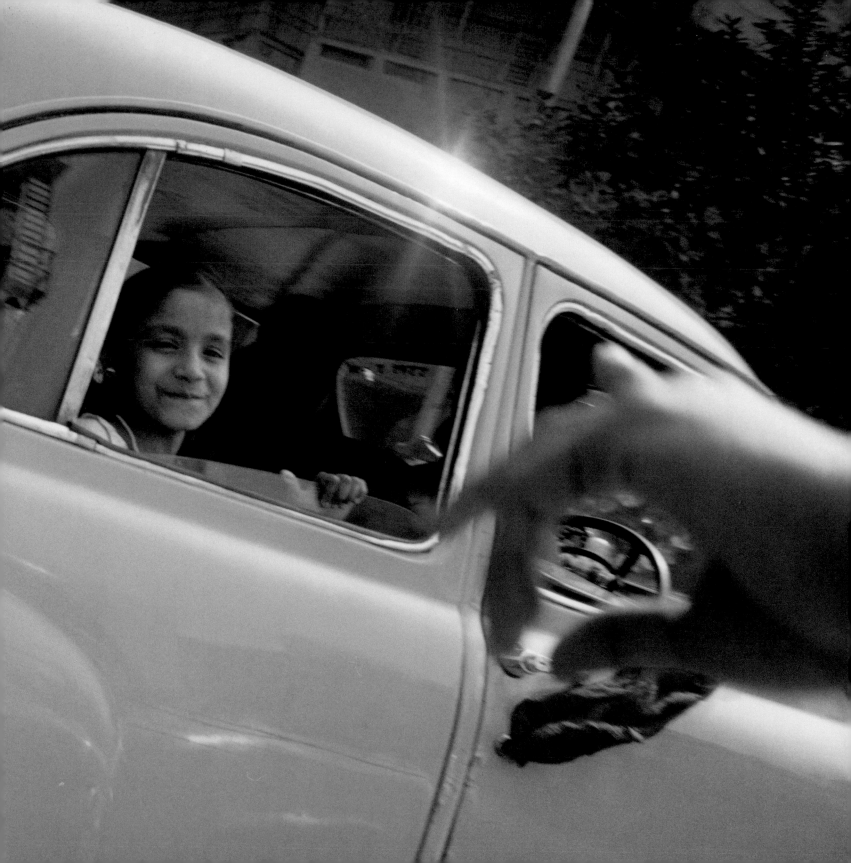

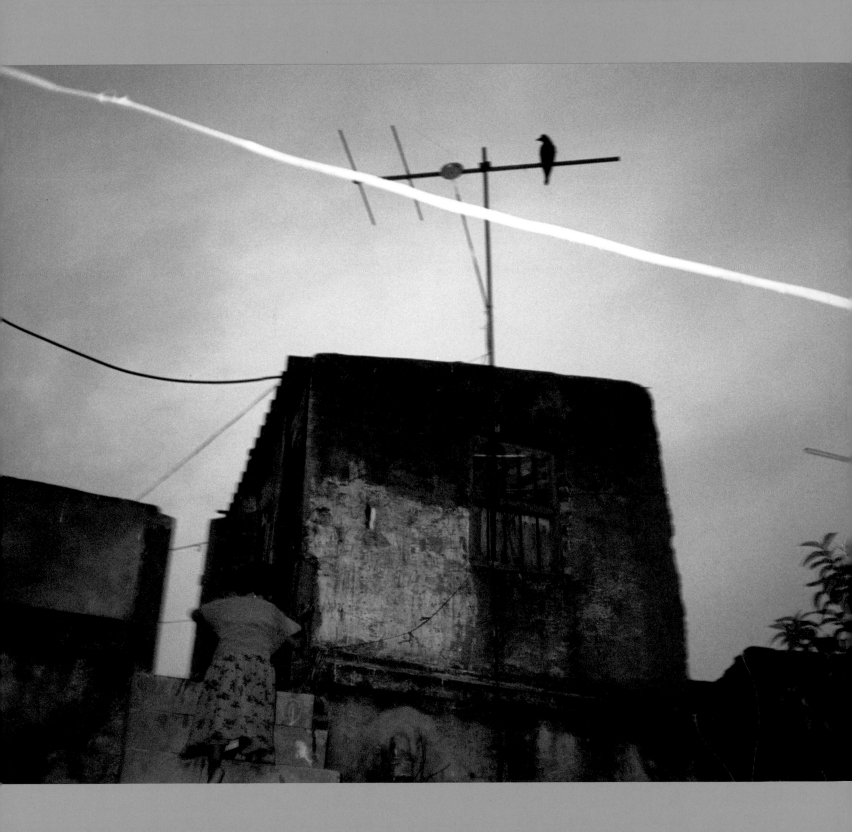

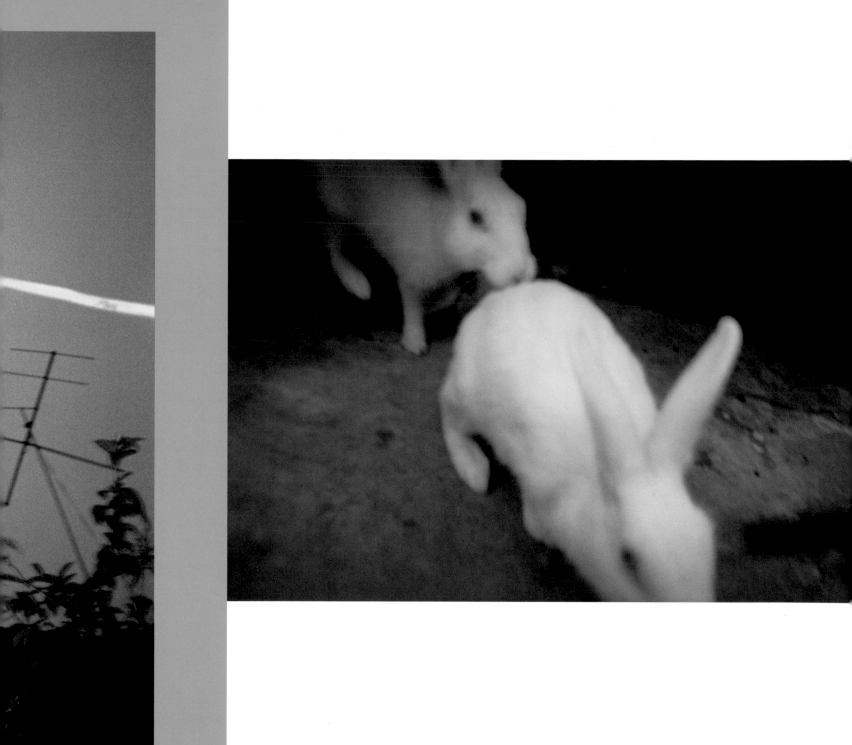

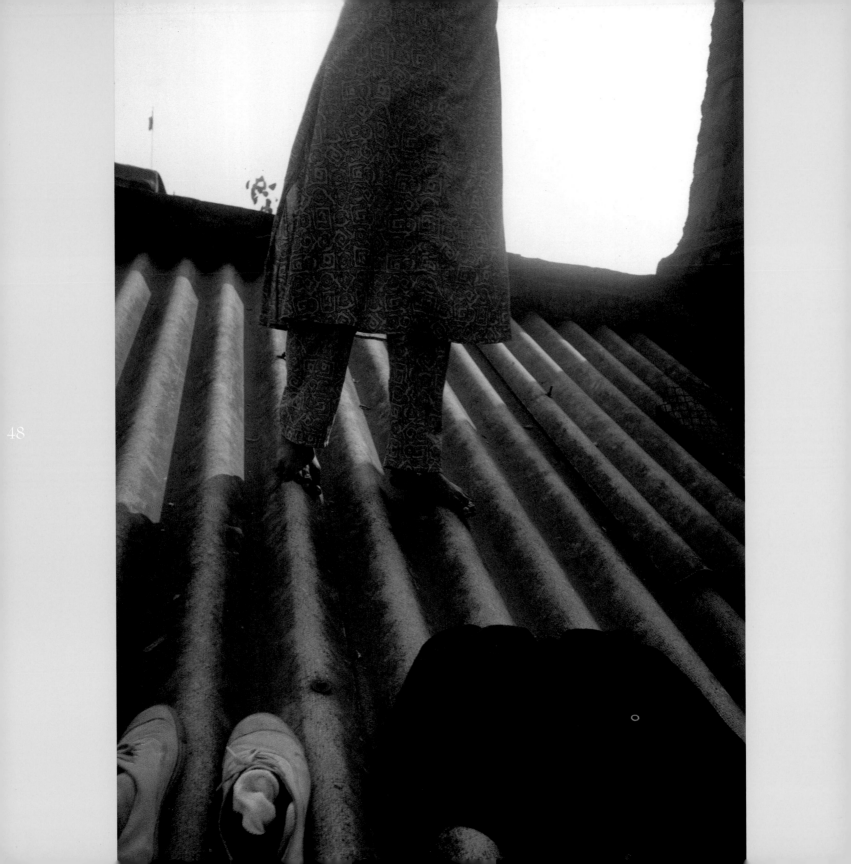

48

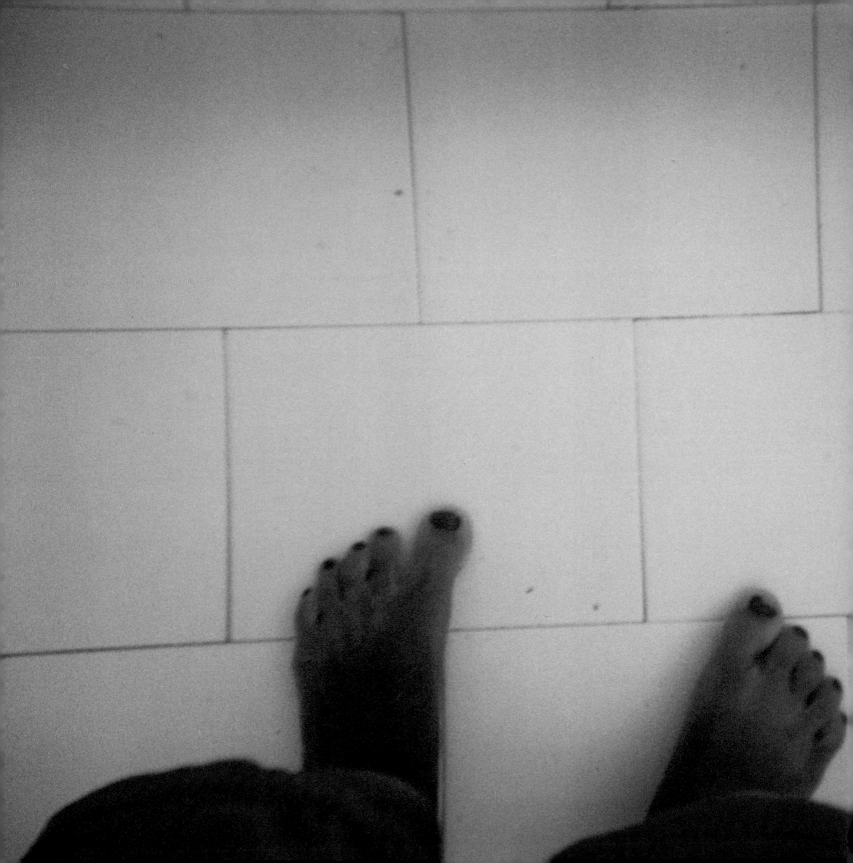

Kochi

Kochi, ten, is shy and sweet. She did not live in the neighborhood, but in another brothel some distance away, so she did not know the other children at all. At the beginning of the class she kept mostly to herself, speaking only a few words. Over the course of the term, her confidence grew and grew. She opened up and became a part of the group. She uses the camera to escape her surroundings, taking pictures instead of animals, gardens, and parks. She says she prefers taking photos to editing them. She now lives at the Sabera Foundation home for girls and is learning English and computer skills. In Kochi's words: "I feel shy taking pictures outside. People taunt us. They say, 'Where did they bring those cameras from?'"

51

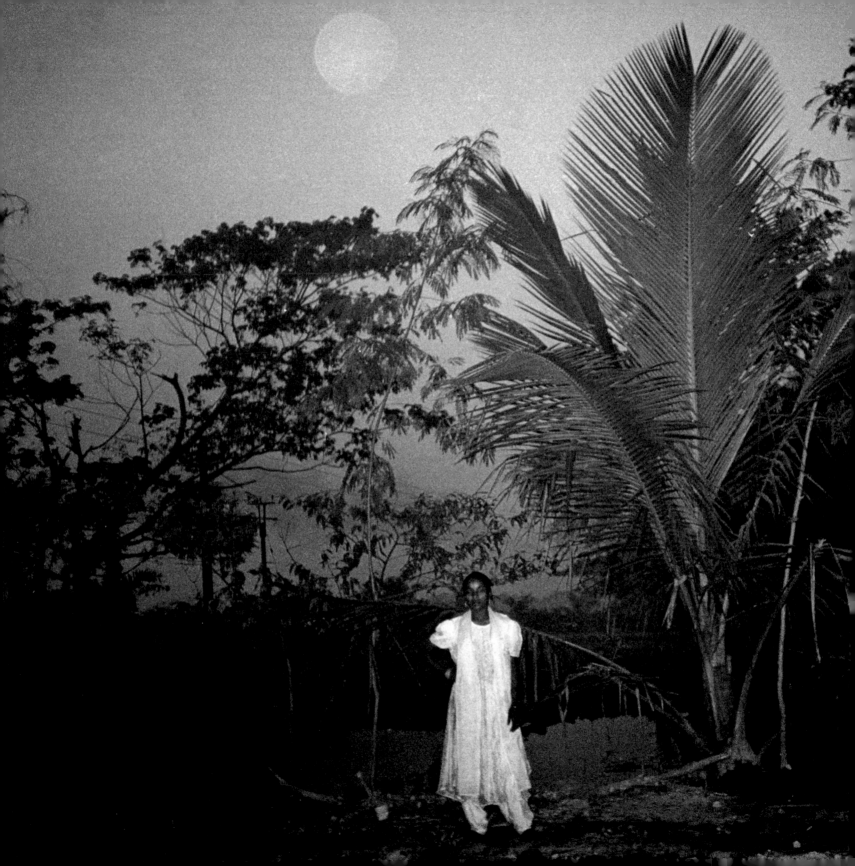

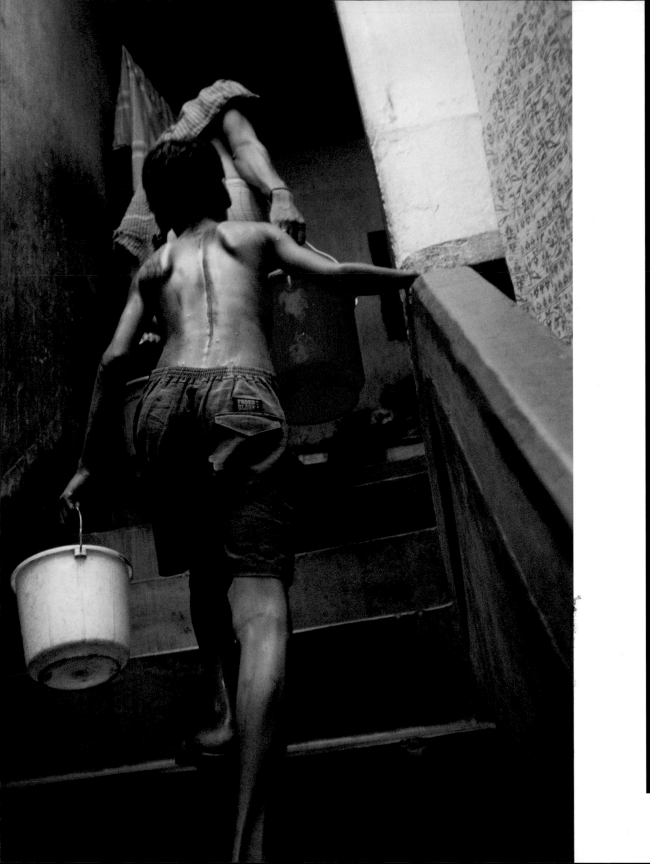

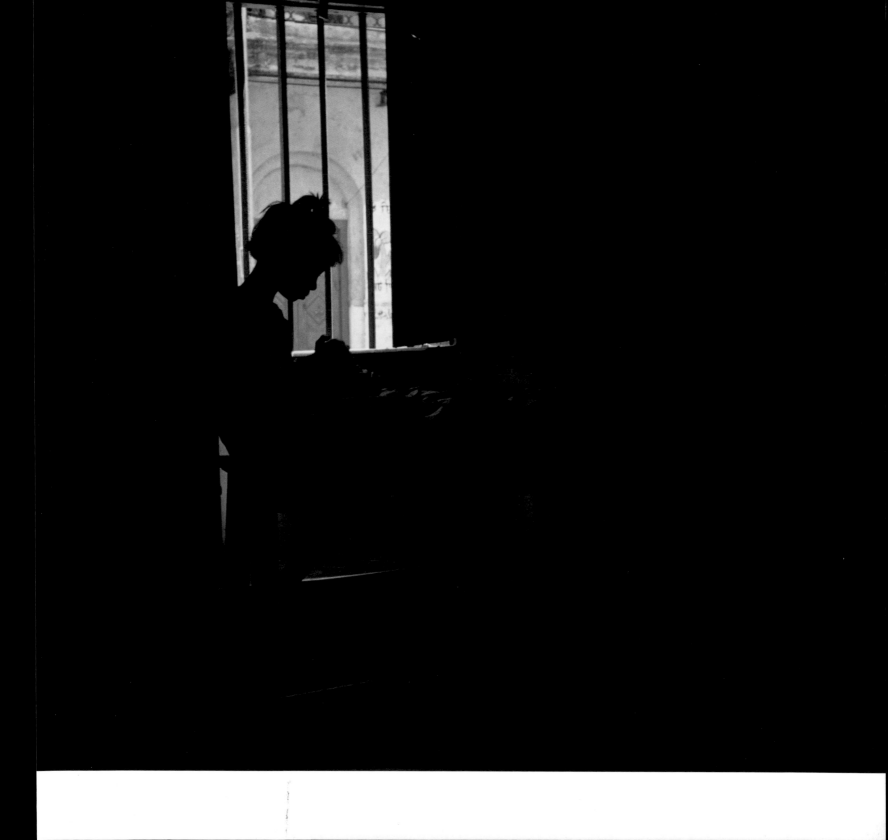

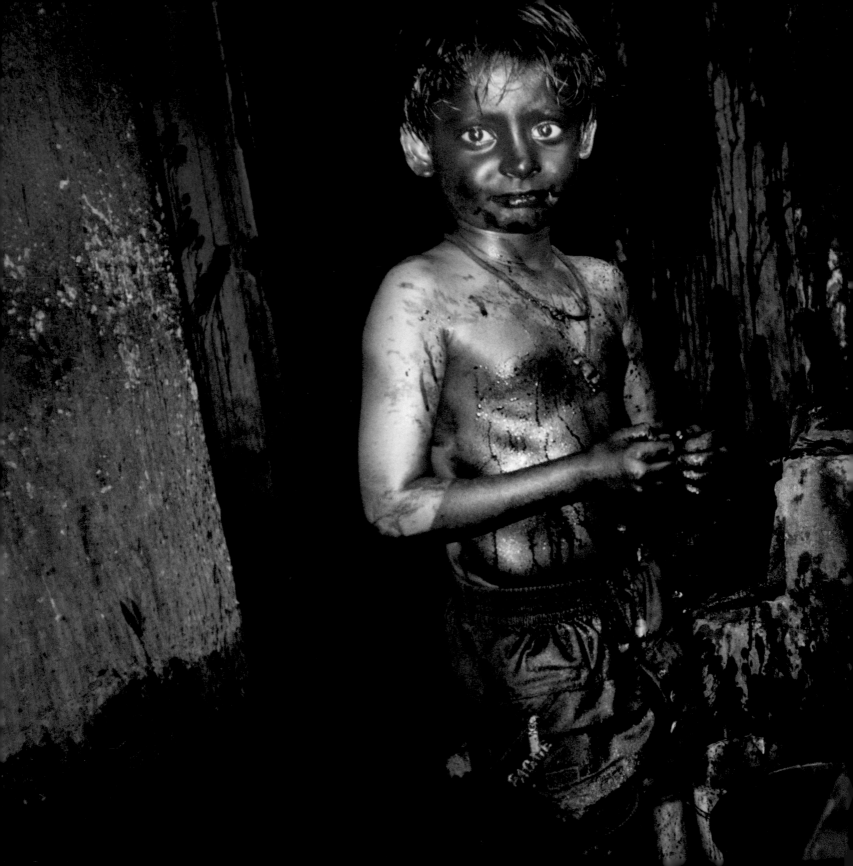

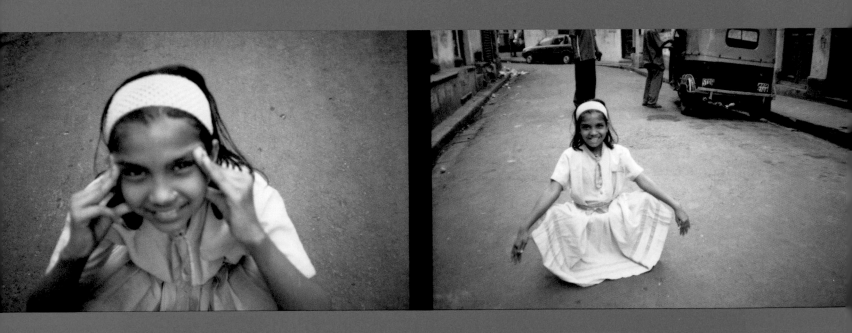

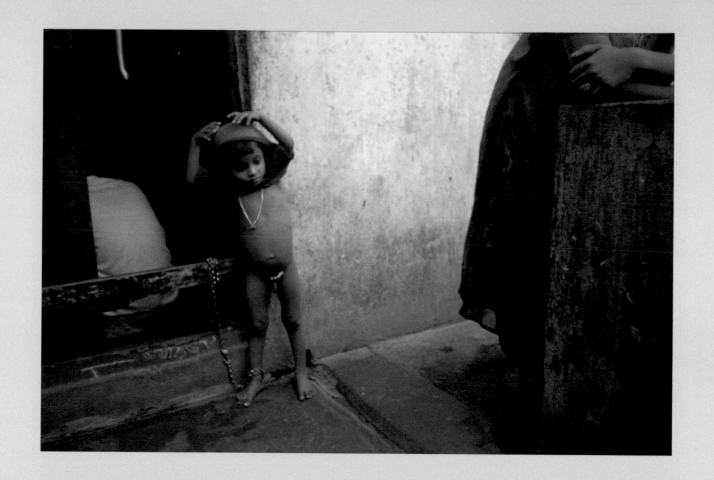

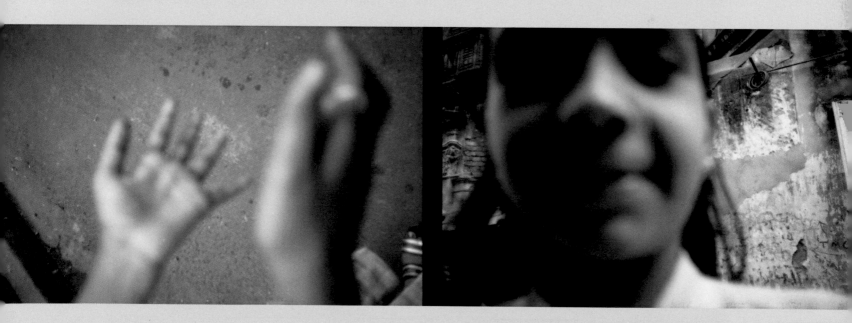

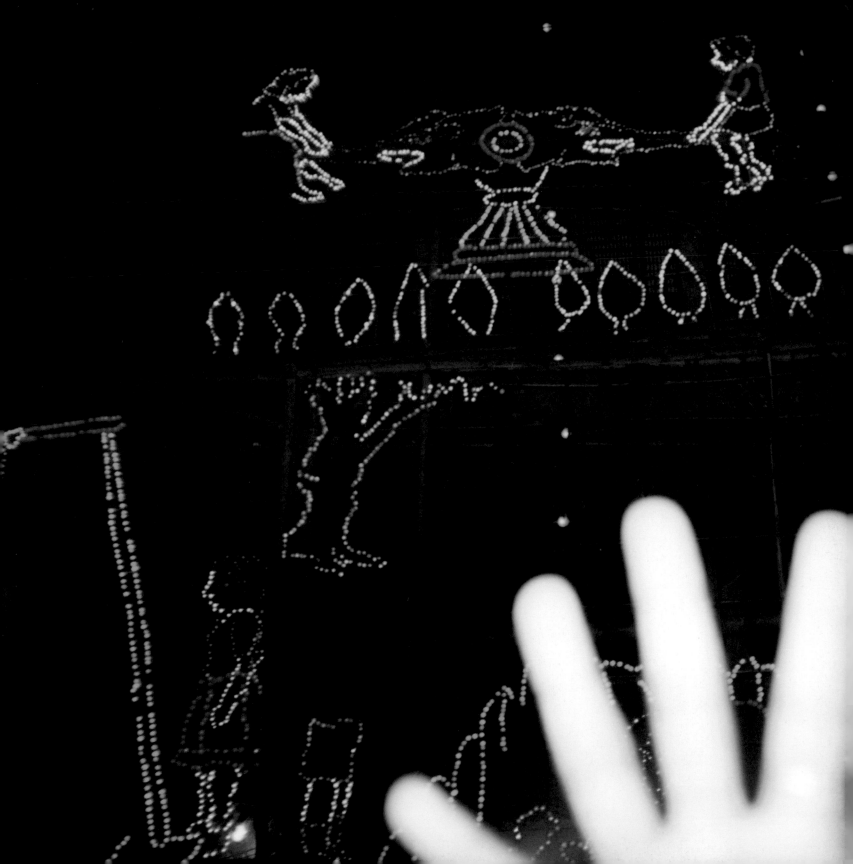

Manik

Manik, ten, loves to fly kites. He lives in a small room with his sister Shanti and their mother inside the brothel. Manik is a serious boy and though he is quiet, he is a daring photographer. The class became an adventure for him: "We went to the beach to take pictures. I had never seen the ocean before. I was amazed!" He says he now likes photography more than kites.

61

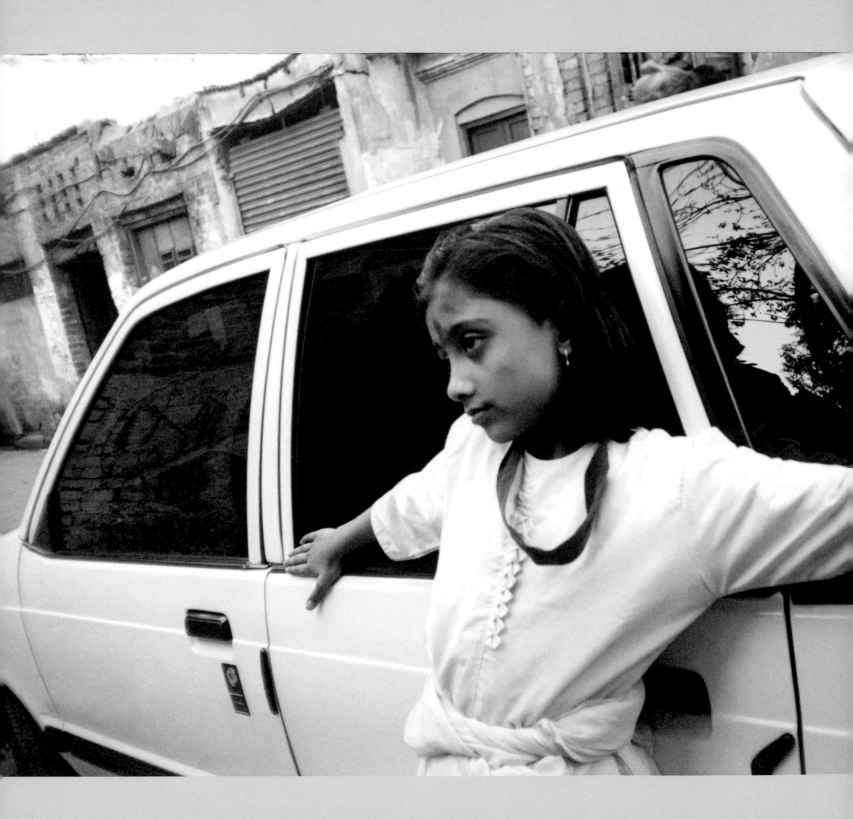

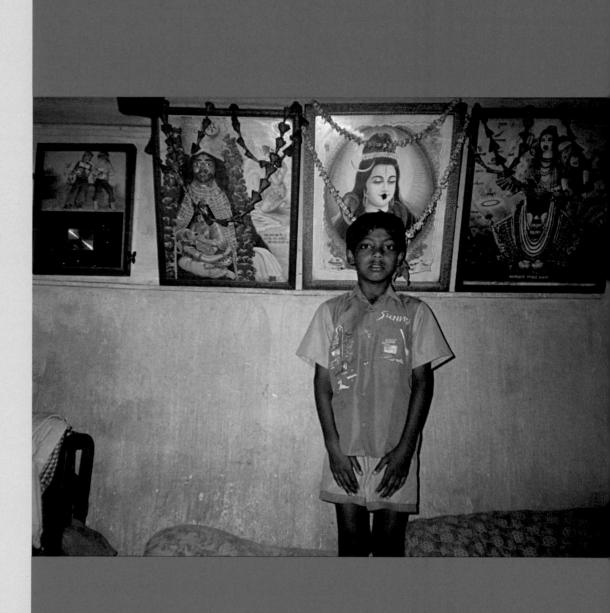

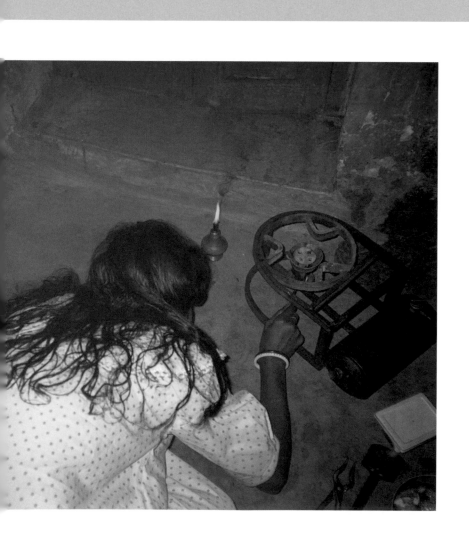
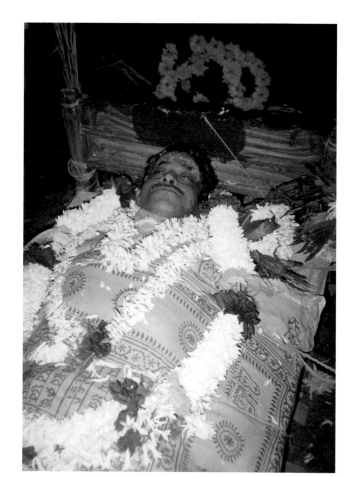

65

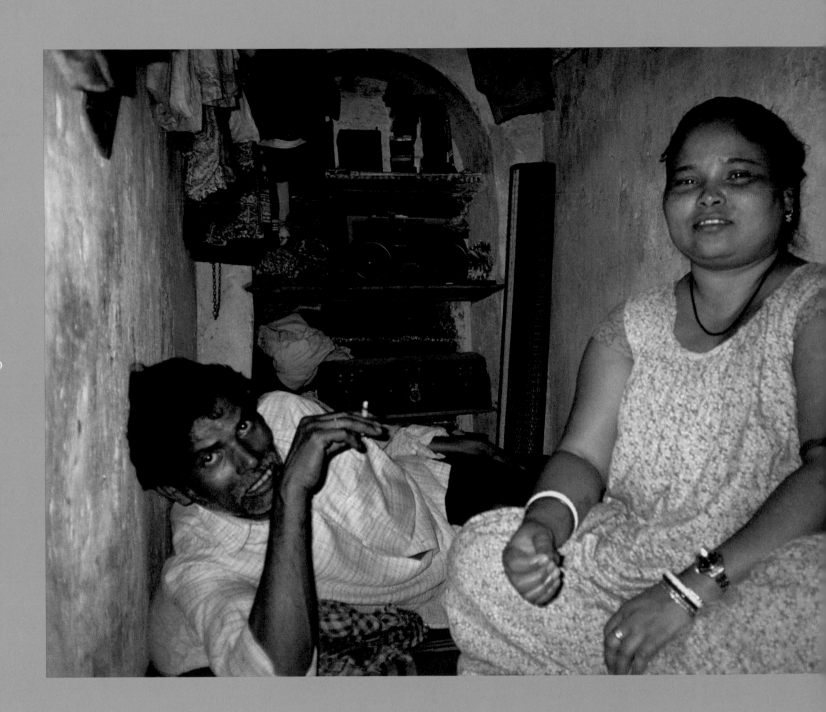

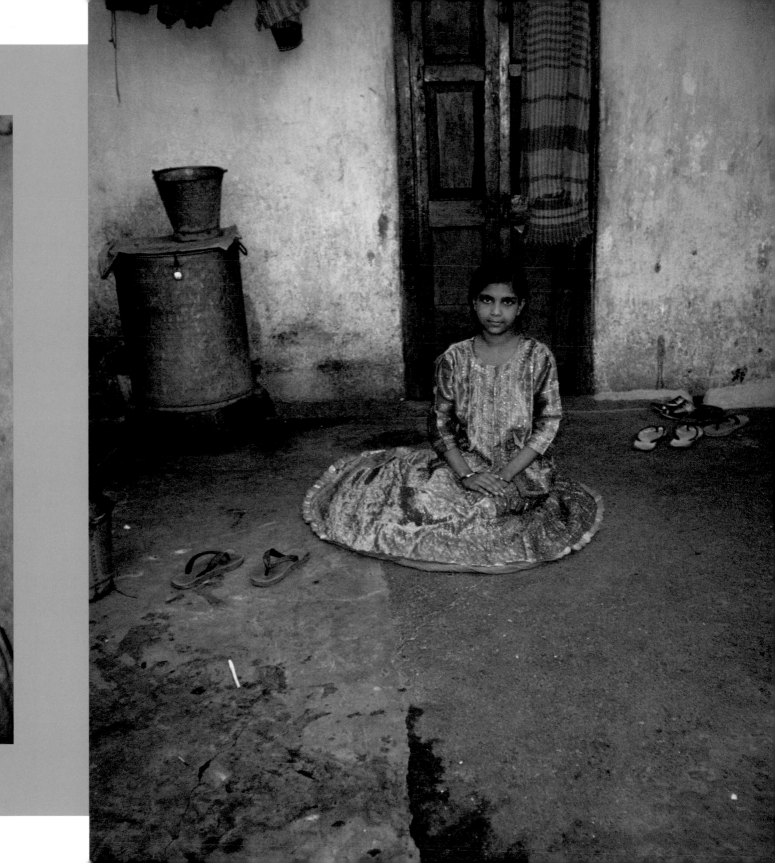

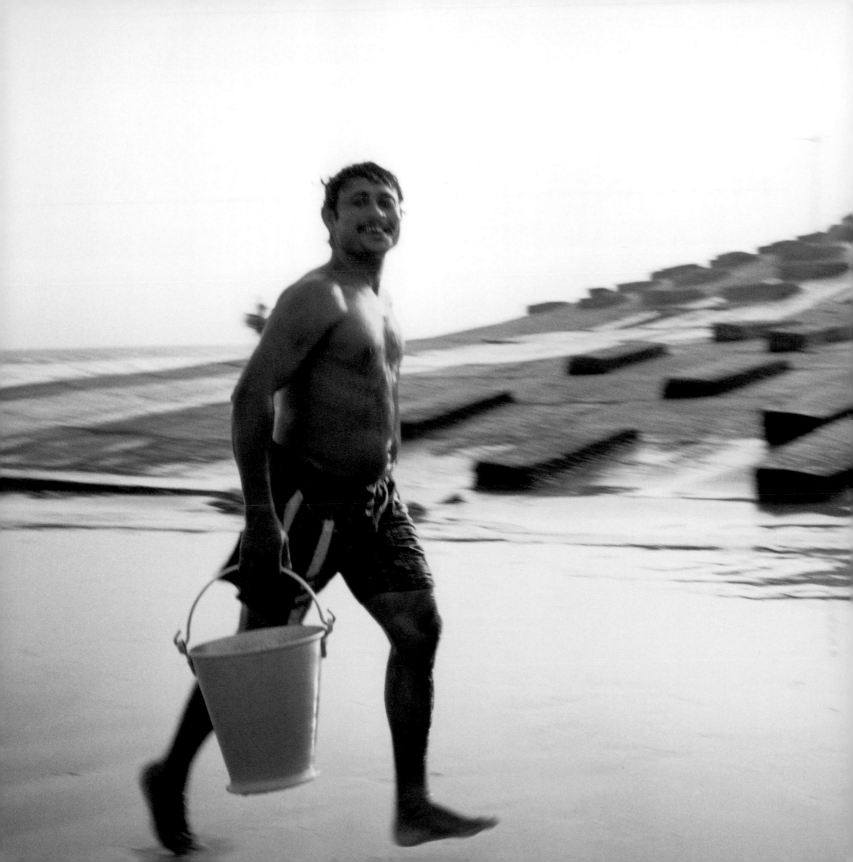

Puja

Puja, eleven, photographs mostly in her room which she shares with her mother, her great-grandmother and her pet parrots. Gour's best friend and a tomboy at heart, Puja used the photography course to overcome her fear of her environment. It gave her the freedom to explore her independent side, away from the sometimes excessive attention of her mother. Gour says of her, "Puja was always naughty and she would not let me take her picture. She would hit me and run away. So one time when she started running behind the car, I moved fast and took her photo." She ended up as one of the few participants bold enough to photograph on the street. Her photographs are rich in detail, describing her interior world. Of her image of a tree she says, "This is a Neem tree that has been there forever. I always see it when I play on my terrace."

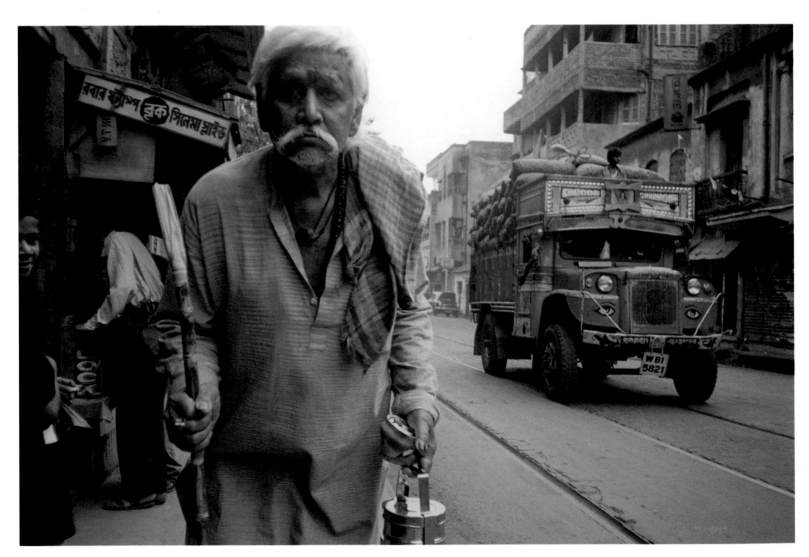

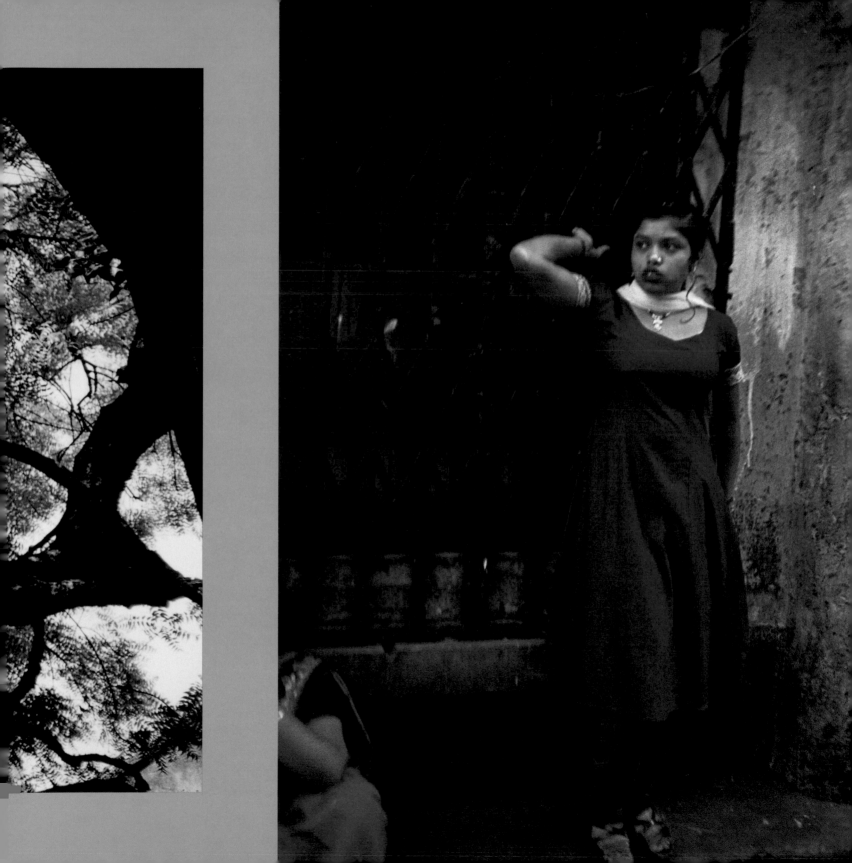

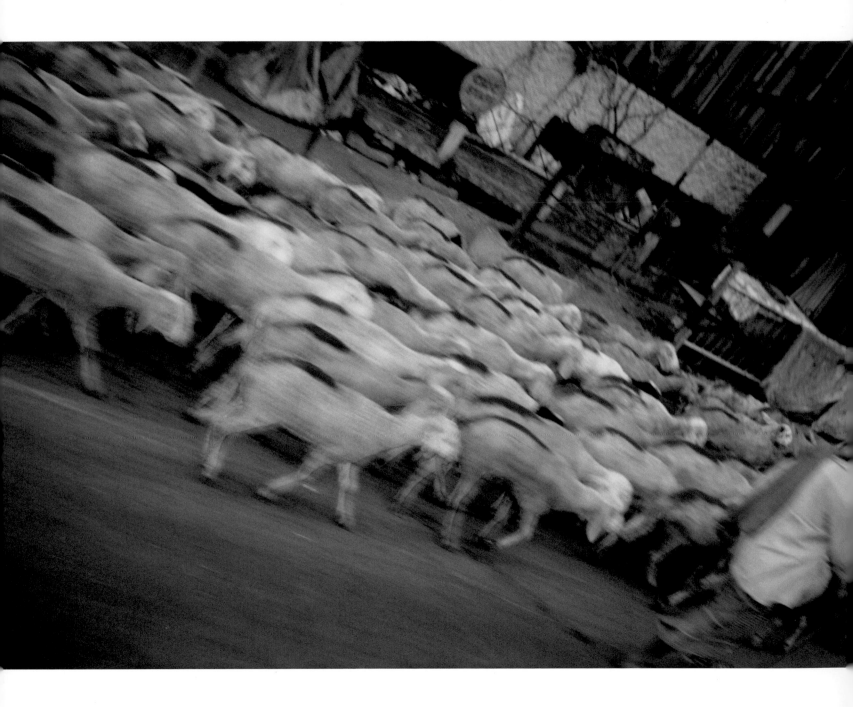

Shanti

Shanti, eleven, lives with her brother, Manik, and their mother. She likes to photograph her family, but likes to use a video camera even more. Shanti actually filmed one of the classroom scenes in the film *Born Into Brothels.* She is an extremely smart girl whose passion sometimes boils over into arguments often in the classrooms. It is no secret that Shanti loved being in front of the camera as much as she loved being behind it. Even Manik was a victim of her scene-stealing: "During the Saraswati festival there were lots of lights and decorations. I began to take a picture of the lights, but my sister Shanti came and put her hand in the way."

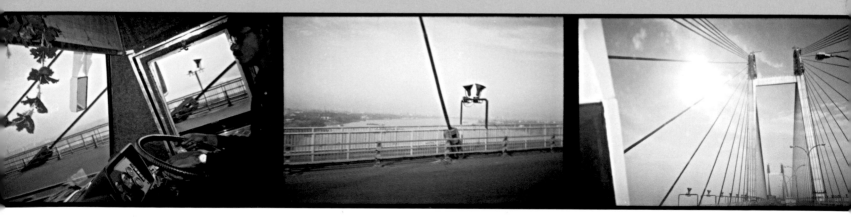

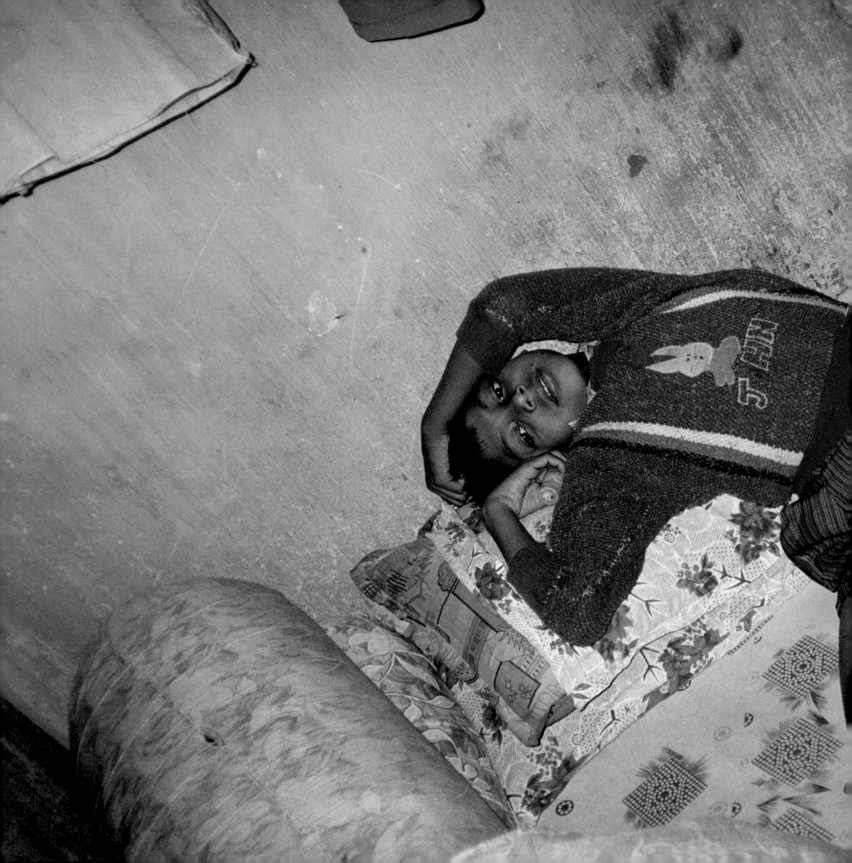

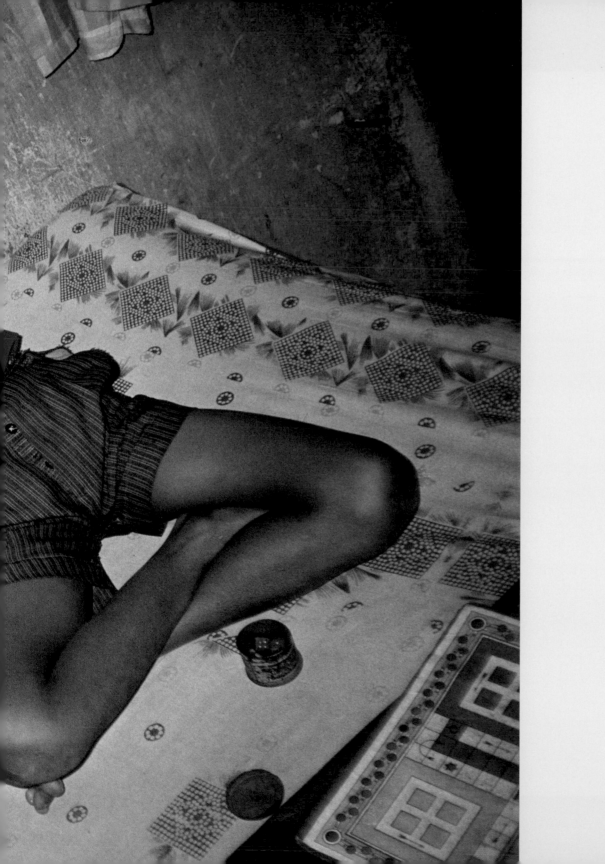

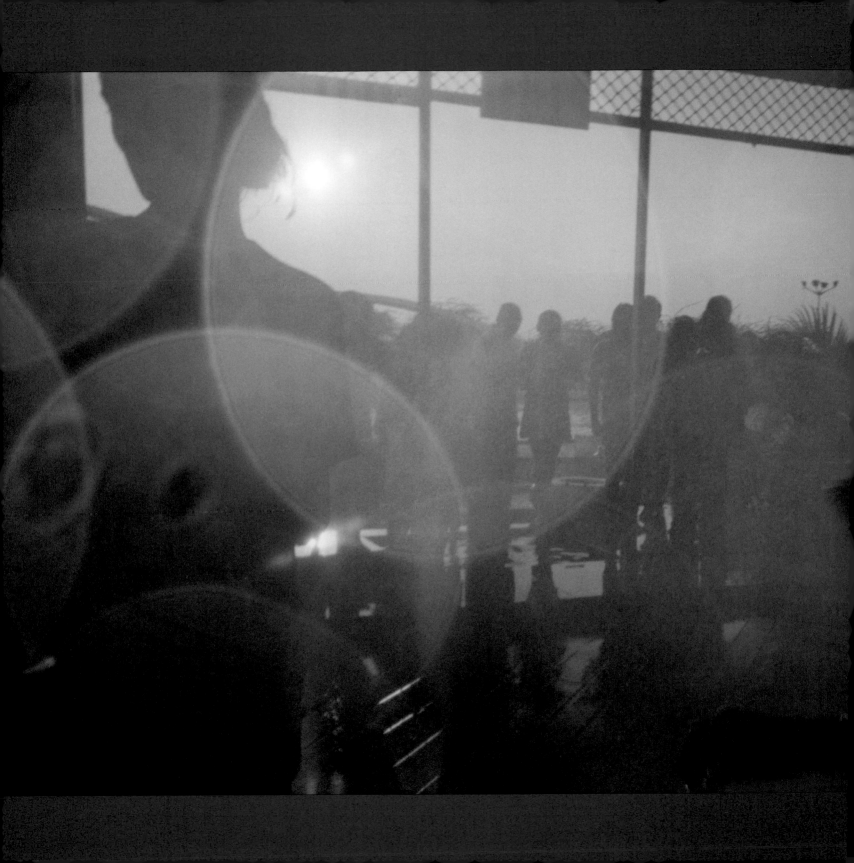

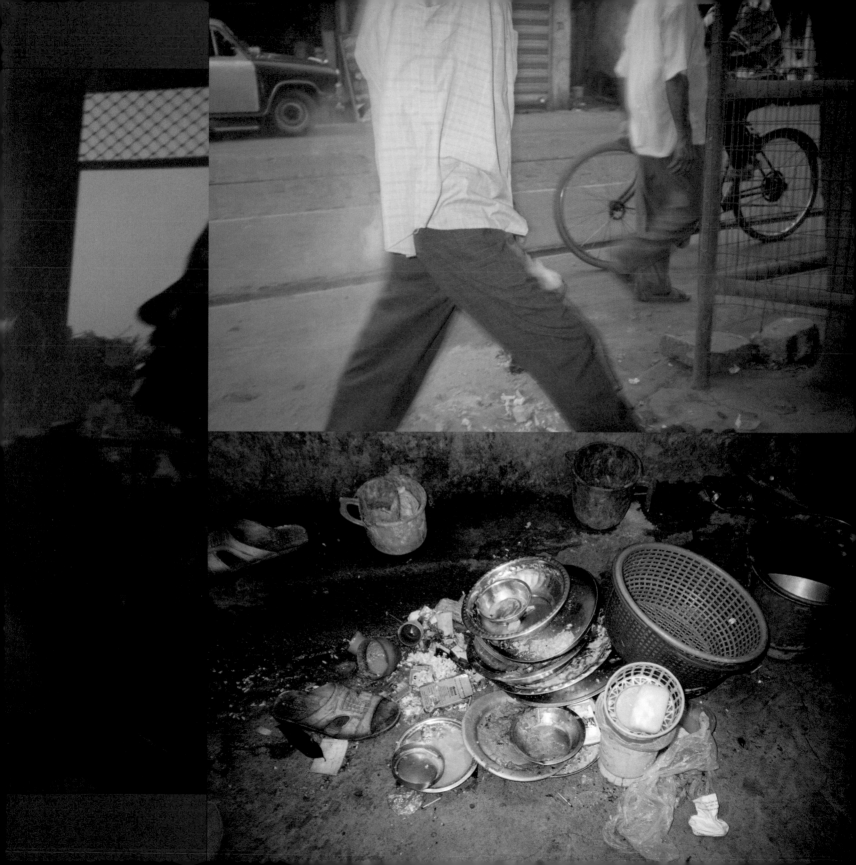

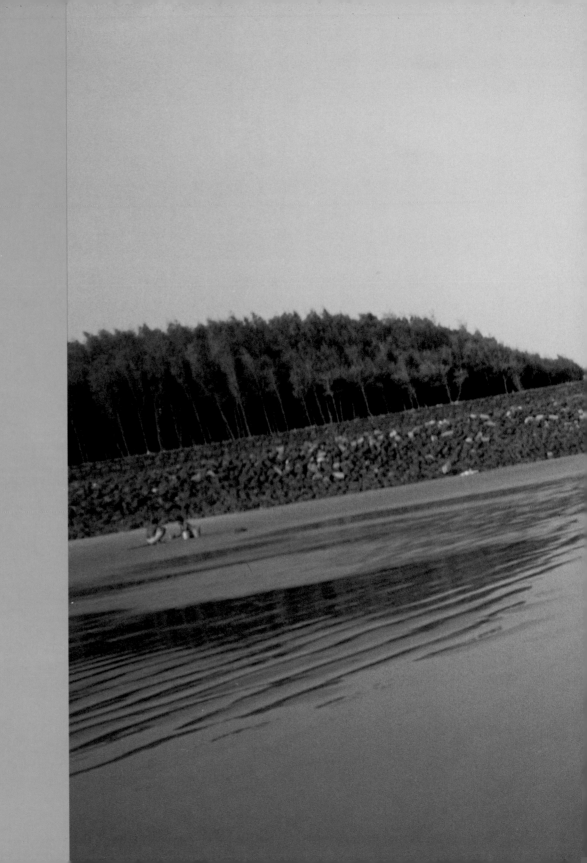

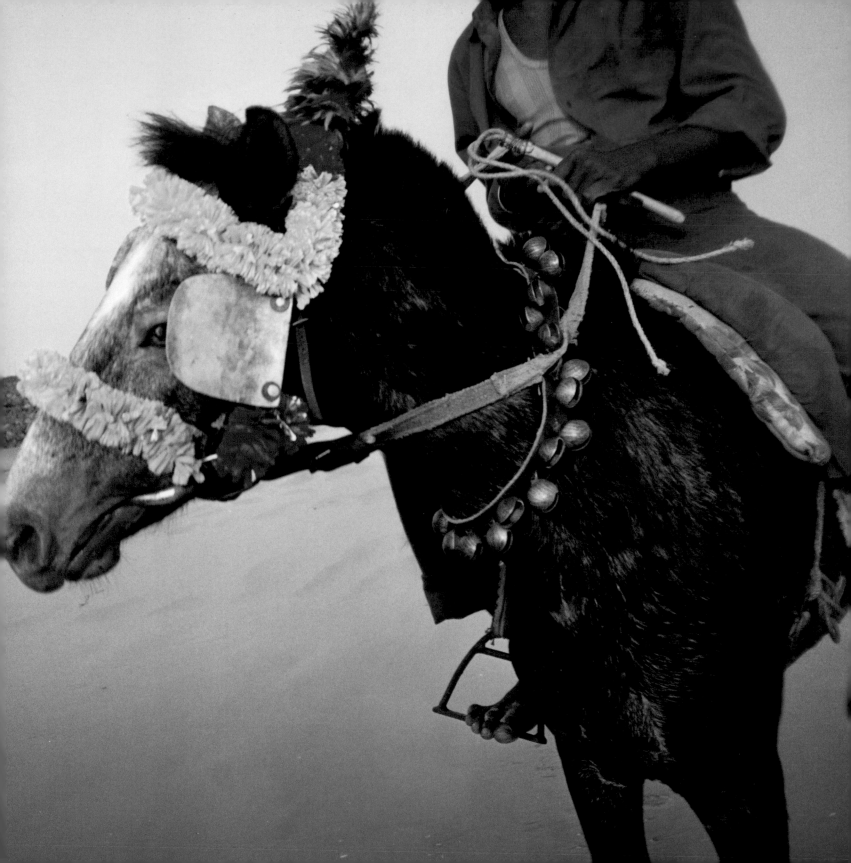

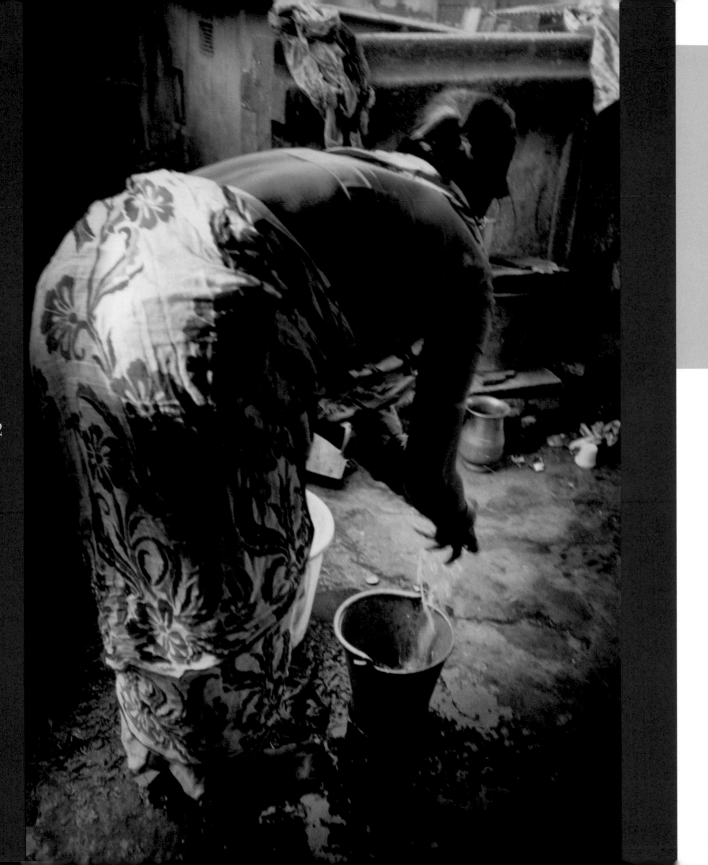

Suchitra

Suchitra, fourteen, is a gifted photographer, taking photographs of daily life on her rooftop. She says, "When I have a camera in my hands, I feel happy. I feel like I am learning something. I can be someone." Her mother died very young and she was raised by an aunt. She was reluctant to photograph outside in the street, feeling instead more comfortable inside the house. She focused on domestic subjects such as laundry and the kitchen cats. Her photo of her sister's friend was chosen as the cover of the Amnesty International 2003 calendar.

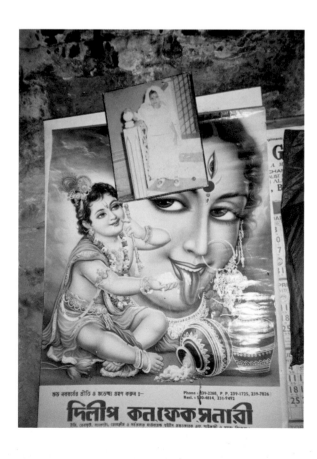
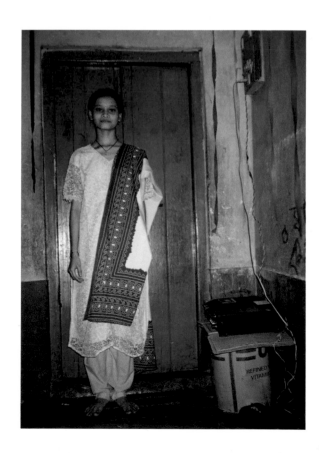

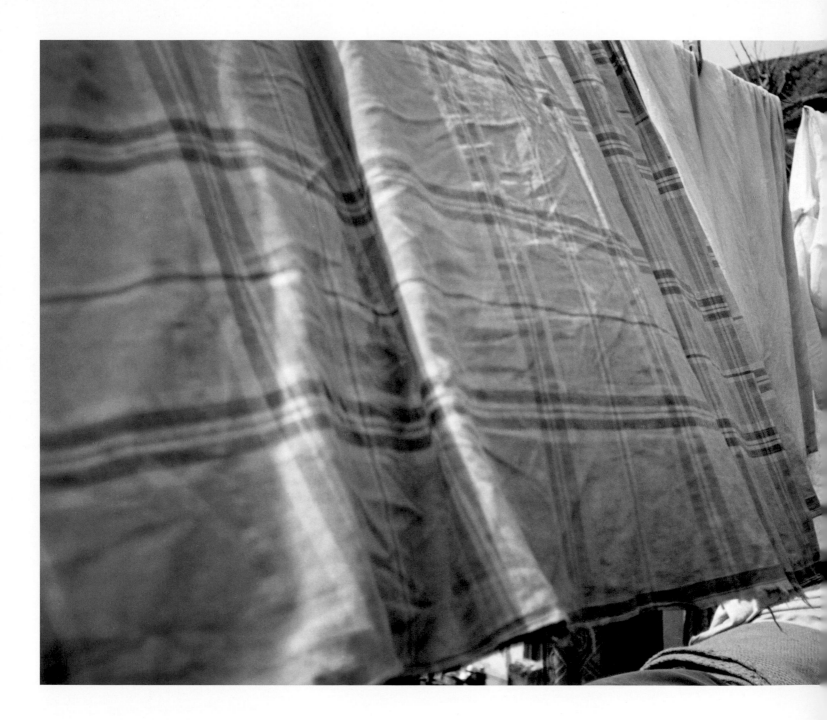

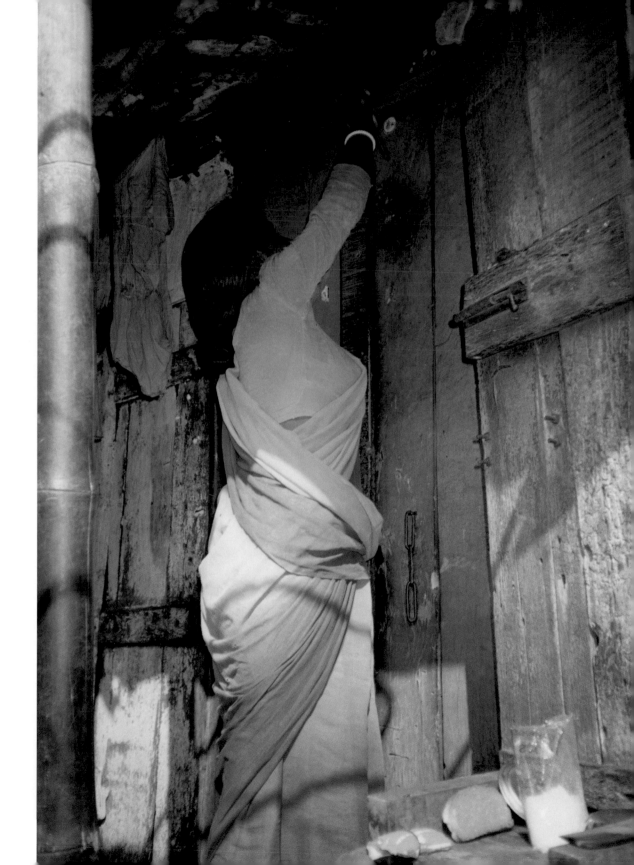

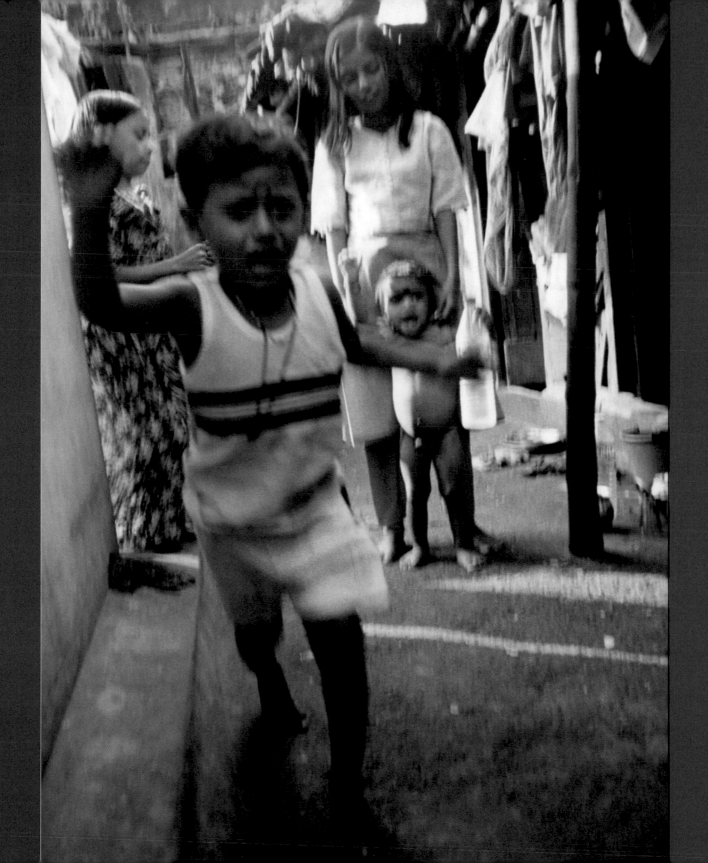

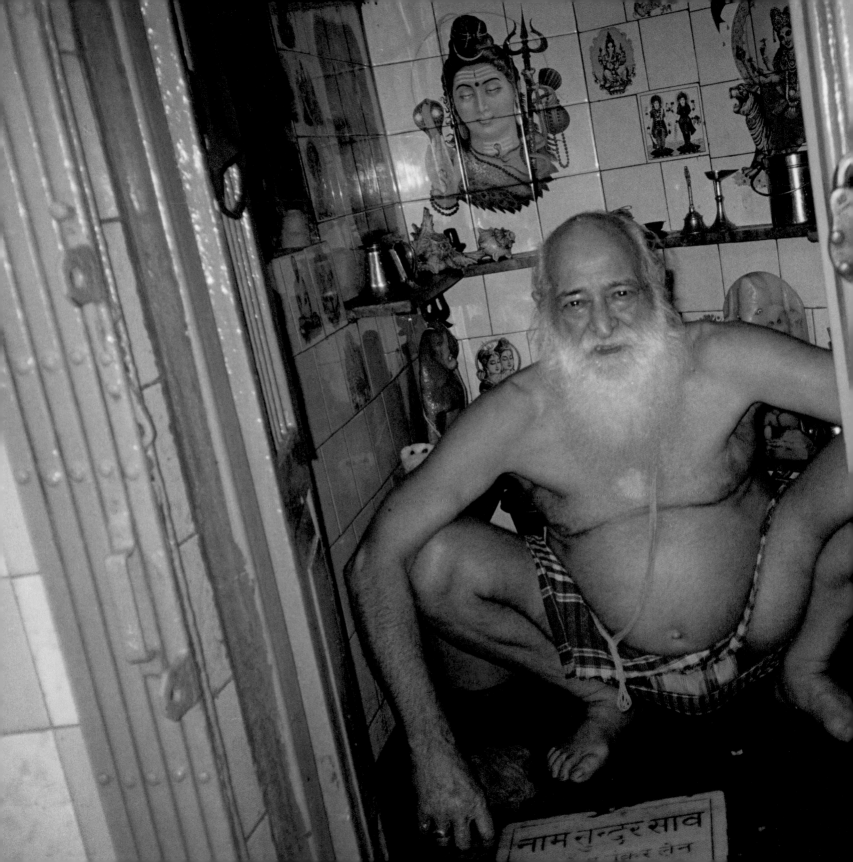

Tapasi

Tapasi, eleven, would like to be a teacher but first wants to take care of her younger brother and sister. Quite possibly the most serious of the group, Tapasi lives with her eyes open to the harsh reality of her life. She works constantly: cooking, cleaning, carrying water, she gets very little rest daily. Her family are among the very poorest in the brothel. Sympathetic to the girls she sees on the street, she uses the camera to tell the story of her life. She has hidden under her bed to escape the regular police searches ostensibly to capture underage girls working illegally in the brothels and in practice to extract the prostitutes' money. By Indian law, eighteen is the age limit but it is universally flouted. Tapasi now lives in the Sanlaap home for girls.

89

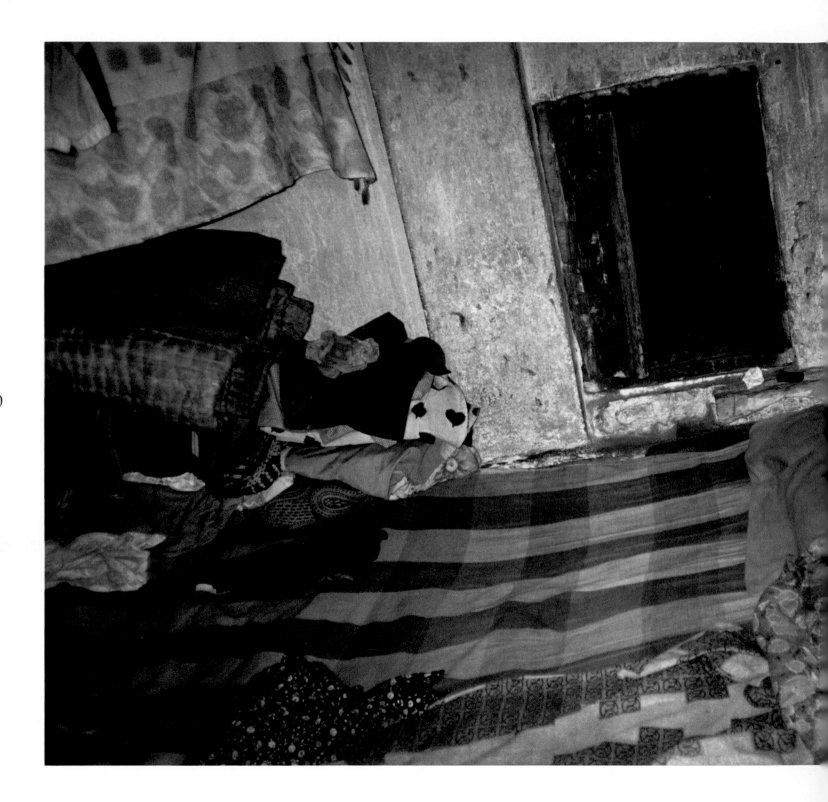

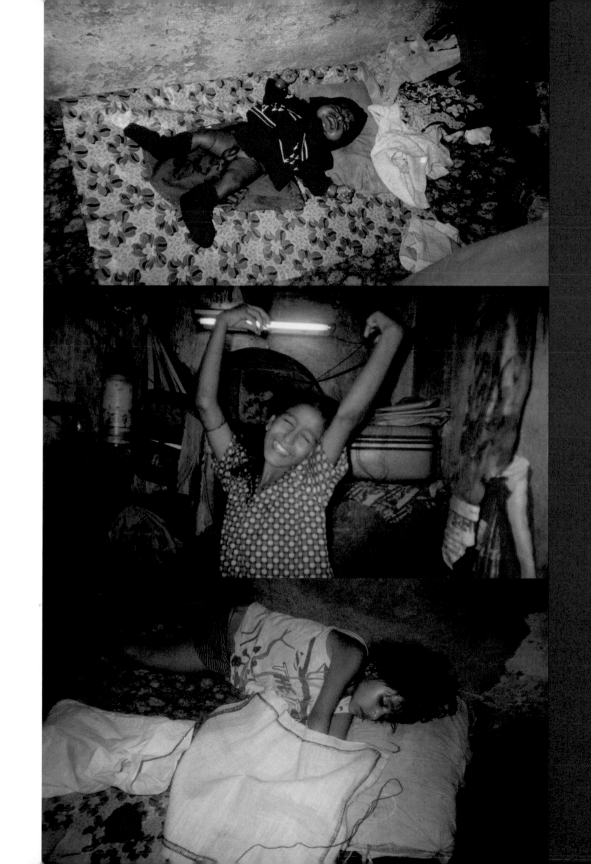

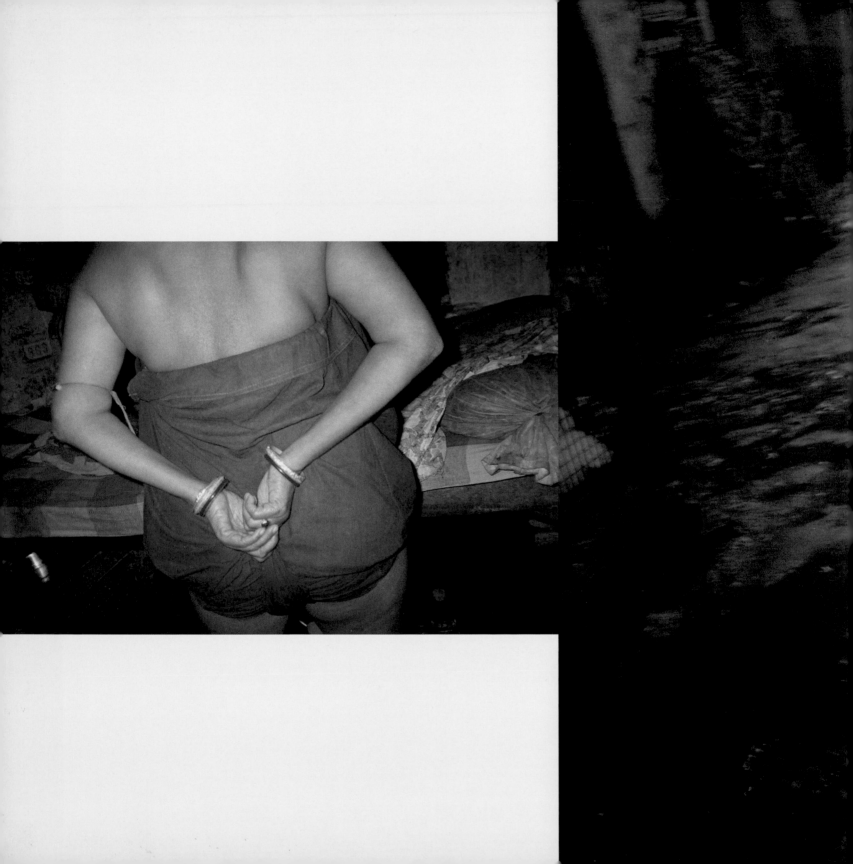

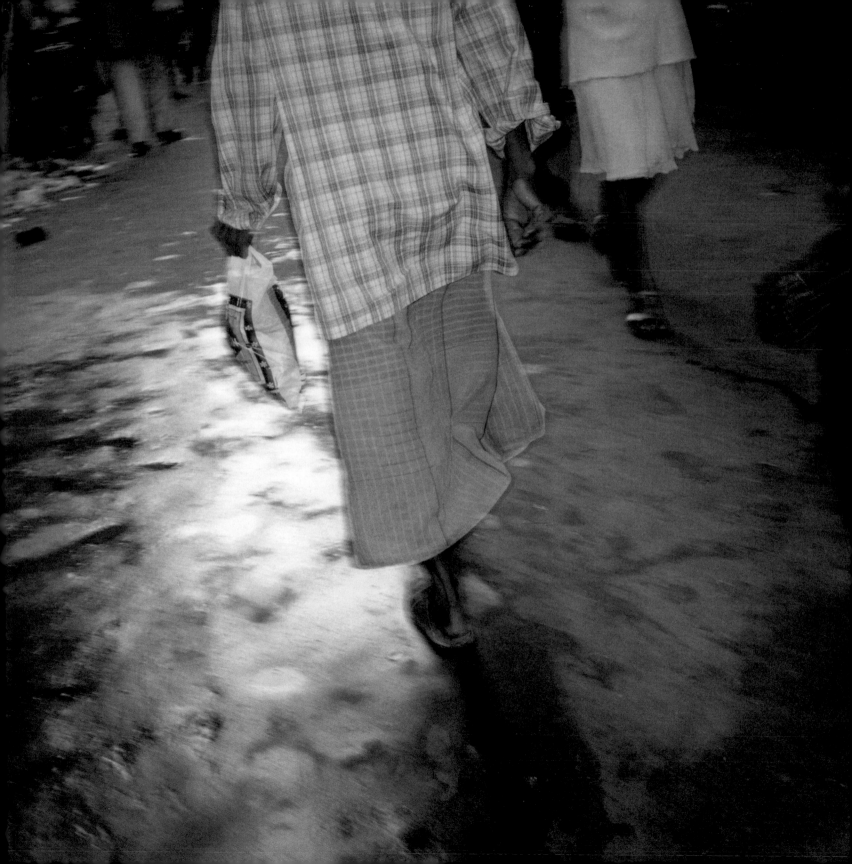

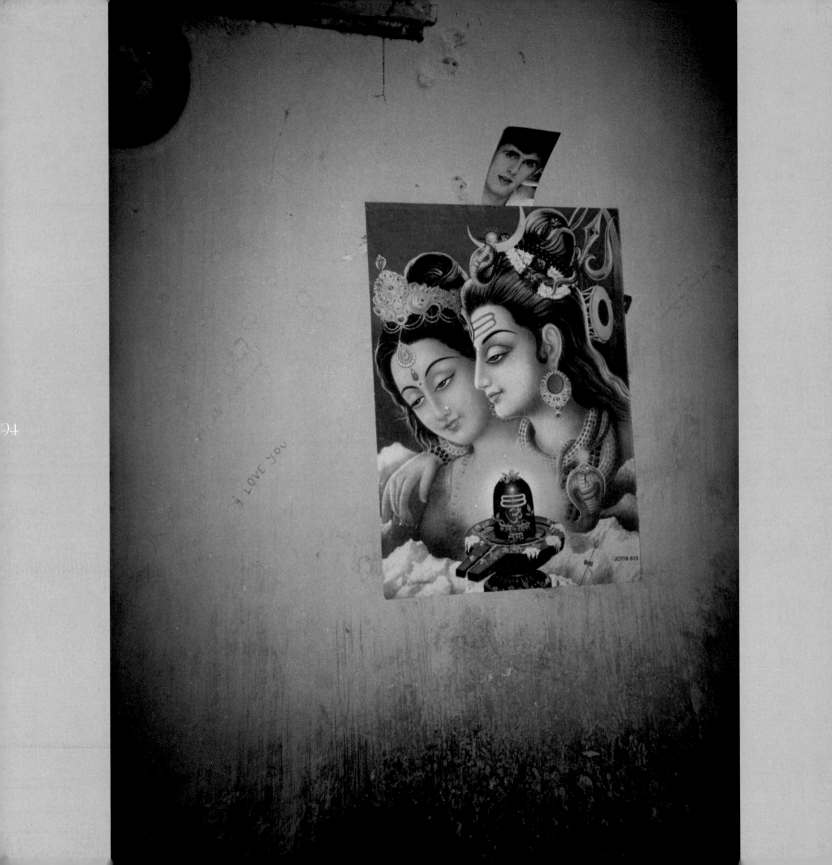

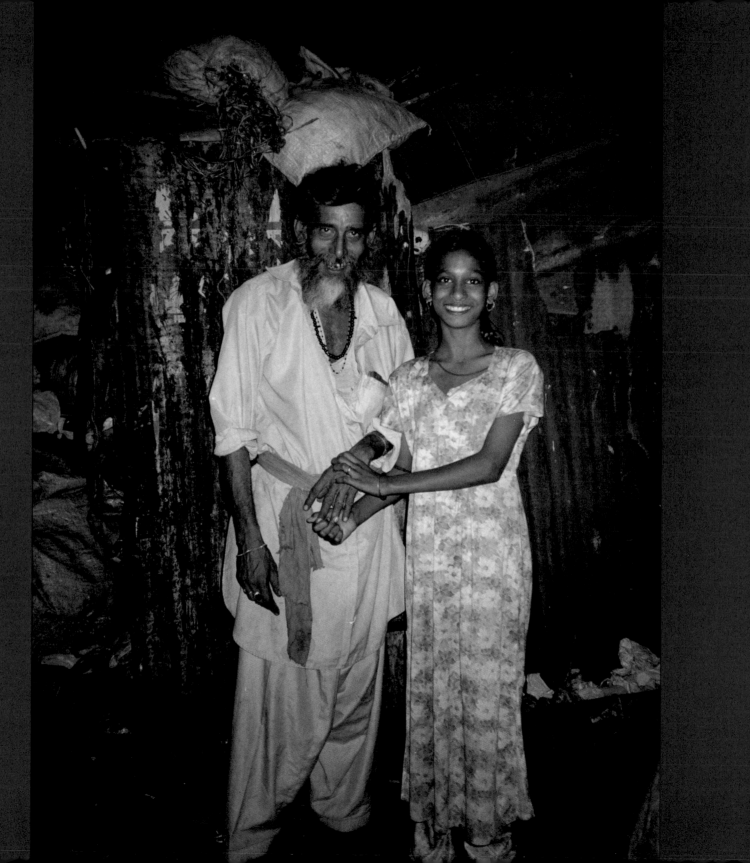

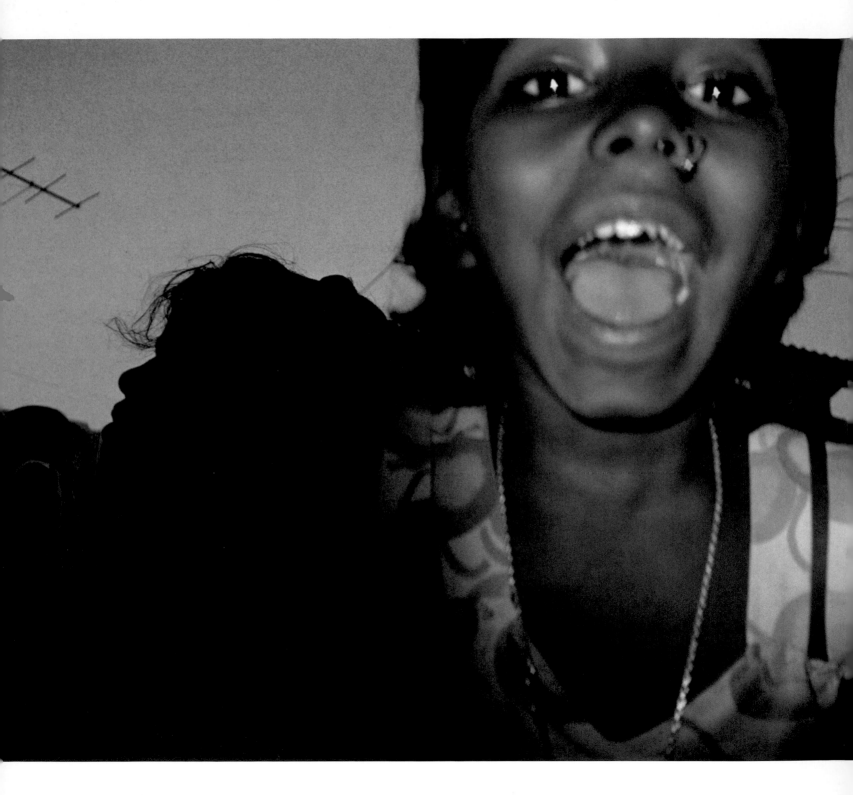

Self-portrait by Mamuni

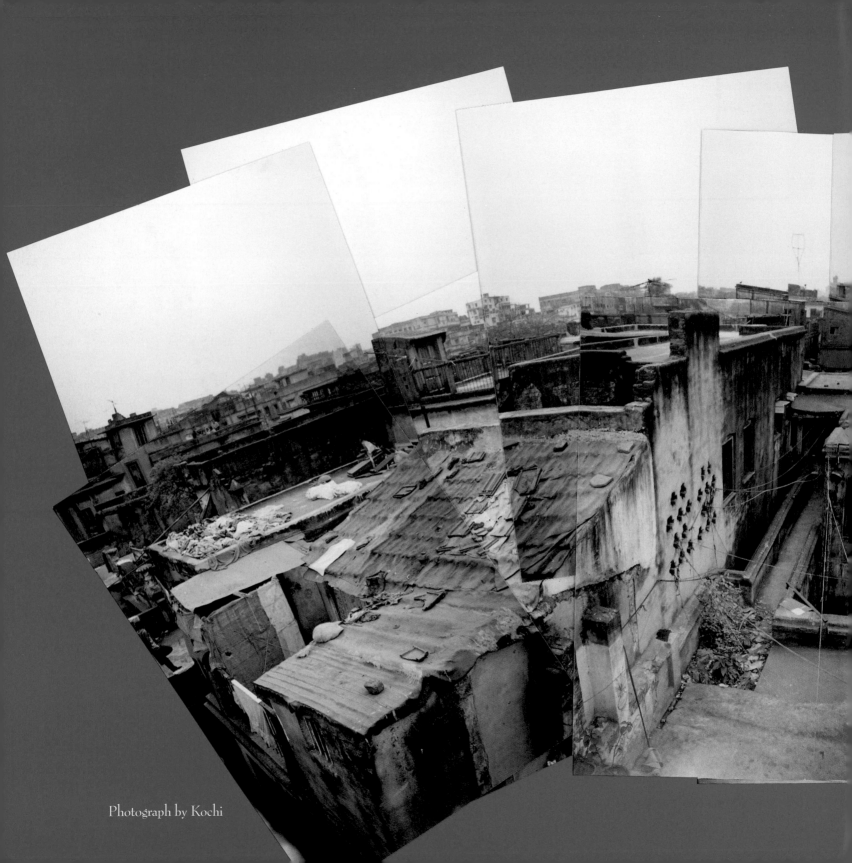

Photograph by Kochi

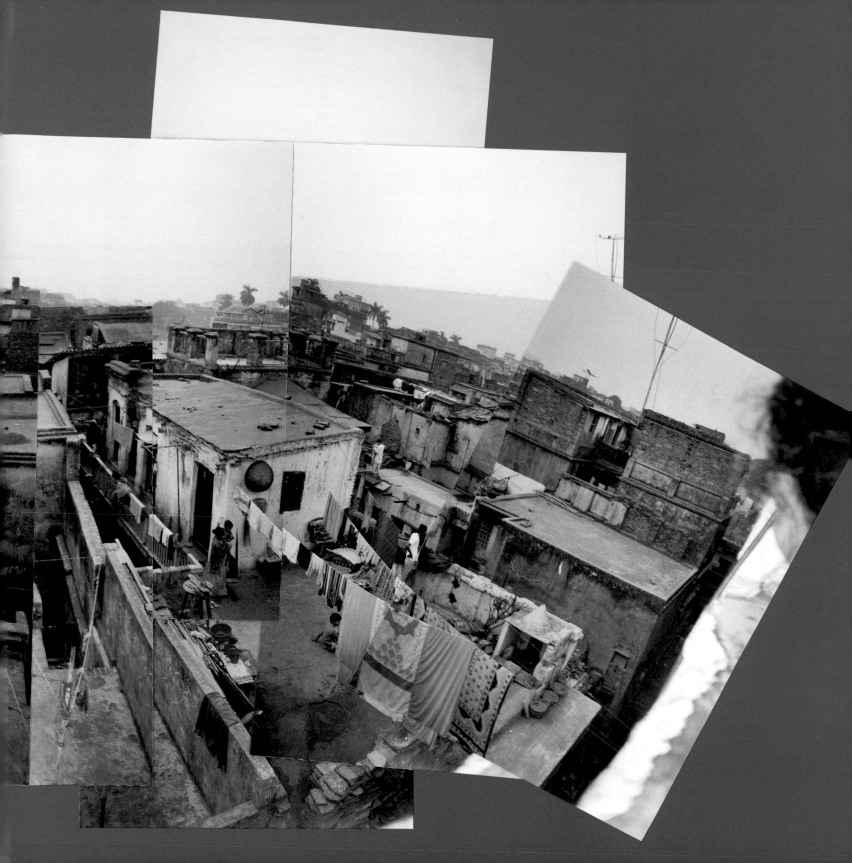

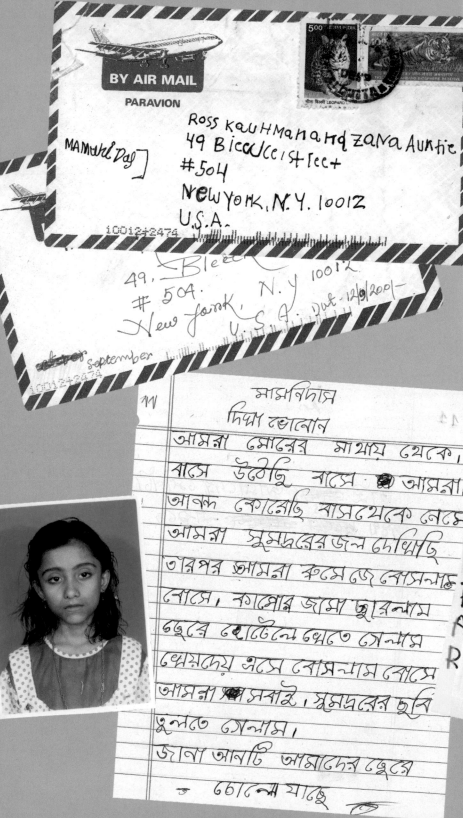

Envelope:

BY AIR MAIL

PARAVION

[MAMudi Day]

Ross Kauhmanahd Zana Auhtie
49 Bleccker Street
#504
NEW YORK, N.Y. 10012
U.S.A.

10012+2474

49, Bleeck
#504, New York, N.Y 10012
U.S.A. Date -12/9/2001-

september

Letter (Bengali):

শ্রদ্ধাস্পদ / সম্মানীয়

আমি ভ্যানাই সুখেসেই আছার কুমার, আমাদের আশীর্বাদ আমি
কালো আছি। আমি আশা করি আনেকতা সবাই ভালো আছেন
ভামসাদের কথা আমার খুব মনে পড়ে, আমরা যে সাইকেল
দিয়েছেন, আমি সাইকেল লেড খুব খুশি হয়েছি আমি
দুবছ বিকেলে । এই সাইকেল চালাই আমার ইস্কুলে কলেজে
কেরিয়েছি তবে আমি লেখা করি অমতো শেষীতে উঠেছি কিন্তু
ফলাফল ভালো ভালো হয়নি, ইস্কুলে অমতো শেনীর ভাবেই বই
এই আমার ইস্কুলে ভর্তি হতে টাকা লাগবে এই আমার
আনার ঝমা একটা বিনীত ধন দয়া করে আমানি কিছু
টাকা পাঠিয়ে এমে আমাকরি, আমরা কেমন আমন আমাদের
জানানো চিঠি লেখ চিঠির ভিতর একেন, চিঠিত কোন রকম ভুল
হলে ক্ষমা করবে একেন

ইতি

গৌর বর্মন

Handwritten page (Bengali):

মামনিদাস

দিপ্পা দেভানোন

আমরা মোরের মাথায় থেকে,
বাসে উঠেছি বাসে আমরা
আনন্দ কোরেছি বাসথেকে নেমে
আমরা সমুদরের জল দেখলি
তারপর আমরা ক্রমে জে বোসনাম
বোসে, কাশোর জামা ছুরলাম
দুরে হোটেলে খেতে সেলাম
খেমদেয় এসে বোসনাম বোসে
আমরা সবাই, সমুদরের ছবি
তুলতে সেলাম,
জানা আন্টি আমাদের ছেরে
 চোলো যাচ্ছে

New Year card:

HAPPY NEW YEAR
HAPPY
২০০২ ... HAPPY NEW YEAR [repeated ২০০২ throughout]

আন্টিম -, ZANA আর MAD ROSS ভালবাসা

তোমরা-কেমন, তোমরা-নিশ্চই-ভালো-আছো তোমাদের-আমার-অনেক
তোমাদের- ভালোবাসা- উমা-উমা তোমার- উঠি-যে তোমার,
অনেক- দিন- হোলো- তোমার- কোন- খবর- পাইনি, মা-তোর
আমি-তোমাকে- চিঠি- পাঠাবো, তুমি-তোমাদের- কেমন- চলে
কেমন, তোমরা- ডাকাতে- আলোচন তোখে, কলকাতার-আমার-
মায়ের-তার, সংসার- হয়- না, আমি- মোর- চলে- মা-যে,
শান্তি- টিভেক বড়লো হুরুদ্ধ- করছে, তোমার-ভালো-মন-
তুমি- কোন- খা- ও-বিধিনী-ভারত-করেছো, আমি-
তোমাদের- ভায়ে-জন্য-আছে; ভালো- থাকিও-তুমি- সুখে-
থোক- ও-তোমার-কে- ভালো- রেখো, তোমাদের-ভালো- তোমার-
মন- খুব- খারাপ- করছে; তোমান-তোরা-তাড়াতাড়ি- এসো-
আবার, তোমরা-আমাকে-চিঠি-পাঠাবে, তুমি-মা-যে-বড়
ও-আমরা-তার-তুমি-তোমাকে, আন্টি- কর্ব- তোমরা-মন-
শান্তিতে- থেকো

ইতি- আনমারী-প্রিয়া

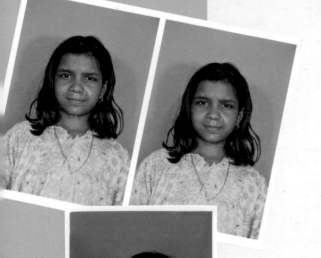

হর পাতা অকুড়
রুই
লাল
যেন তোমার ভে
চিরকাল।।
rm-Arijit

BY AIR MAIL
PARAVION

Ross Kauffman and Zana Auntie
49 Bleecker Street
#504
New York. N.Y 10012
U.S.A

Acknowledgments

I would like to thank the children who opened their hearts and their minds and shared their extraordinary talents, humor, and wisdom with me: Kochi, Avijit, Gour, Puja, Manik, Shanti, Tapasi, Suchitra, and Mamuni. You have inspired countless others by sharing your lives and vision. We are touched and I am deeply honored.

I would like to thank Ross Kauffman who took the risk and made the leap without knowing what he would find. Thank you for your courage, for bunny smuggling, for finding me a pint of Ben and Jerry's in Indonesia after seven months of deprivation in India, for making me laugh, for traveling the path of love. And for making a damn good film.

Countless thanks to our Executive Producer and friend Geralyn White Dreyfous. At Kids With Cameras we just refer to her as Goddess. What would we have done without you? Thank you, Jim Dreyfous, for supporting us and for sharing Geralyn.

To our friends at HBO, especially Sheila (auntie) Nevins and Lisa (auntie) Heller, thank you so much for believing in us, supporting us and for allowing our film to reach millions of viewers. It has been a true pleasure working with you.

Thanks to our supporters of the film: Diane Weyermann and everyone at the Sundance Institute; Robert Byrd of the Jerome Foundation; Don Palmer of the New York State Council on the Arts. Deepest thanks to Pamela and Hunter Boll, Susan and Jim Swartz, Diana Barrett and Bob Vila. You made this film a reality and we are forever grateful.

Thanks to all those who supported the workshops along the way: Robert Pledge who took the kids under his wing and to everyone at Contact Press Images who supported the project; Fred Ritchin and everyone at Pixel Press; our friends in Aspen, Janie Joseland Bennett, George Stranahan, and everyone at Digital Arts Aspen, especially Charlie Abbott, Michael Stranahan and Nikki Beinstein.

Thanks to our wonderful team at Kids With Cameras: Cristina Linclau our intrepid exhibition co-ordinator (aka Sherpa) who has devotedly schlepped the exhibition around the country and halfway around the world. You are so much fun to work with. Kristy and Craig Severance, who have made me computer enabled and savvy. Kristy, you are truly amazing! I am so grateful for all that you do and all that you are. Lina Srivastava, our consultant and soon to be Executive Director—here's to building a School of Leadership and the Arts so that we and the children can fulfill our dreams.

Our deepest thanks to Alyson Winick, of Schwebel's Bakery in Ohio. We met at Sundance and you have faithfully followed us to countless festivals ever since. You have given your heart and soul in support of us. We love you and your bread.

Thanks to those who supported the workshops in the early days: The Open Society Institute, with special thanks to Gail Goodman; and the Howard Chapnick Grant for the Advancement of Photojournalism.

Thanks to those who helped in Calcutta: Tumpa, Raja, Priya Darshininandy, Arup Sengupta, Bishakha Datta, Sanlaap, the Sabera Foundation, Future Hope, and the Society for Indian Children's Welfare. Special thanks to Malobika Chaudhuri for translating, for caring, and for supporting us in Calcutta.

Special thanks to our doctor, Bart Kummer, MD, who treated us with wisdom and compassion for everything from parasites to Hepatitis E.

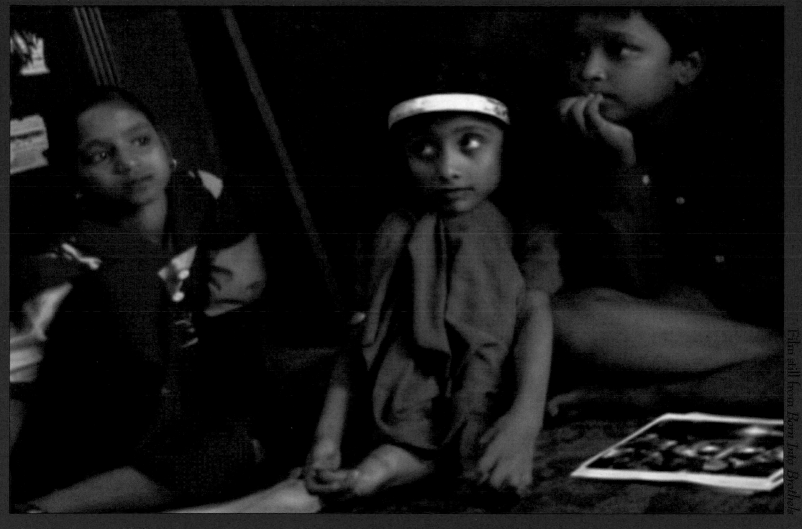

Film still from *Born Into Brothels*

Thanks to our publisher, Nan Richardson, and everyone at Umbrage Editions, especially Emily Baker, our book designer, Andrea Dunlap, and Amy Deneson. In the first photography class in the red light district, I asked the kids if they wanted to make a book of their photography. Four years later, the dream has come true. Thank you for making such a beautiful book that we are all proud of.

To my dearest photographer friends who have supported me for years and years: Anders, Jason, Victor and Gigi. Here's to the dream. May your books be plentiful and published soon.

Thank you to all the viewers of the film, exhibition, and book. Thank you for allowing me to share this love story with you.

Lokah samastah sukhino bhavantu
Om shanti shanti shanti
May all beings be happy and free
Om, peace, peace, peace